The Bigallo

The Oratory and Residence of

the Compagnia del Bigallo

e della Misericordia in Florence

The publication of this monograph has been aided by a grant from the Samuel H. Kress Foundation

Monographs on Archaeology and the Fine Arts sponsored by

THE ARCHAEOLOGICAL INSTITUTE OF AMERICA *and*

THE COLLEGE ART ASSOCIATION OF AMERICA

XIX

Editor: ANNE COFFIN HANSON

Howard Saalman

The Bigallo

The Oratory and Residence of the Compagnia del Bigallo e della Misericordia in Florence

Published by NEW YORK UNIVERSITY PRESS

for THE COLLEGE ART ASSOCIATION OF AMERICA

New York | 1969

Copyeditor: Miriam R. Koren
Designer: Adrianne Onderdonk Dudden
Typesetter: Quinn & Boden Company, Inc.
Printer: Meridan Gravure
Binder: Quinn & Boden Company, Inc.

For RICHARD KRAUTHEIMER *on his seventieth birthday*

Contents

Preface

This study is dedicated to Richard Krautheimer, who led me into the study of Florentine architecture and taught me a methodological approach to its manifold problems. All scholars, I suppose, have sensed the specter of time behind them, haunting them to completion of a project while there was yet time. In this instance time was short indeed! Less than six months after this work was completed, the waters of the Arno filled the lower galleries of the Uffizi, housing the books of the *Conventi Soppressi,* including the complete archives of the old companies of the Misericordia and the Bigallo.* This book, therefore, is dedicated also to all those who helped to save the books of the Florentine archives from the disaster of November 4, 1966.

The work was carried out with the support of a fellowship from the American Council of Learned Societies in 1963–1964 and during my tenure as R. H. Kress Fellow at Villa I Tatti (Harvard University Center for Italian Renaissance Studies), Florence, in 1964–1965. My thanks are due to Comm. G. E. Fabbrini, ex-President of the Orfanotrofio del Bigallo for his cooperation in permitting access to all parts of the complex. Dr. Marvin Trachtenberg made the photographs for Figs. 1, 6, 11, and 12. The preparation

* Damage to the Bigallo books was relatively light, 395 pieces out of 1801 being affected, none earlier than 1470. For a detailed listing cf. A. D'Addario, "I danni subiti dall'archivio di Stato di Firenze nell'alluvione del novembre 1966," *Rassegna degli Archivi di Stato,* XXVI, 1966, pp. 345–530.

of the line drawings was supported by a grant-in-aid from Harvard University. I acknowledge with pleasure the assistance and advice of my colleague Mr. Howard Burns, King's College, Cambridge, and the editorial assistance of Dr. Anne Coffin Hanson.

H. S.

Carnegie-Mellon University
Pittsburgh, Pennsylvania

List of Text Figures

(Text Figures Follow List)

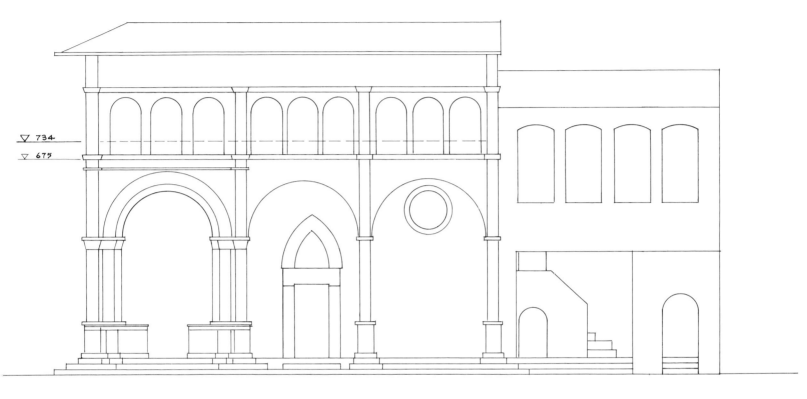

▽ 734

▽ 675

0 5 10 m.

i. Bigallo, reconstruction of oratory and residence elevation.
State before 1442 (after Gerini-Baldese Fresco and Rustici A)

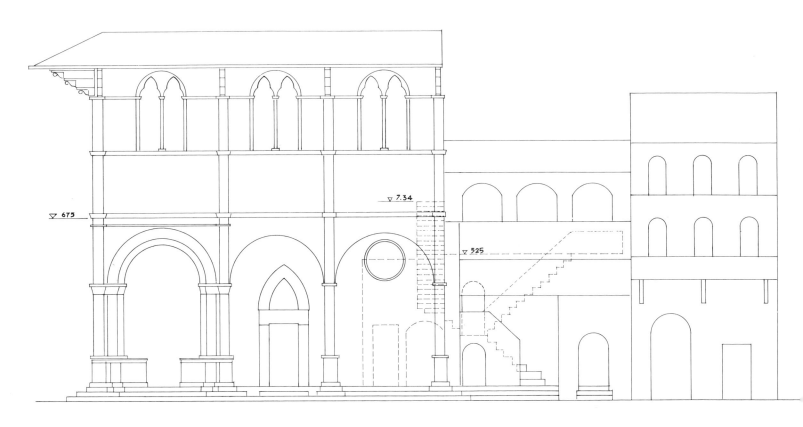

*ii. Bigallo, reconstruction of oratory and residence elevation.
State after 1442 (after Rustici view)*

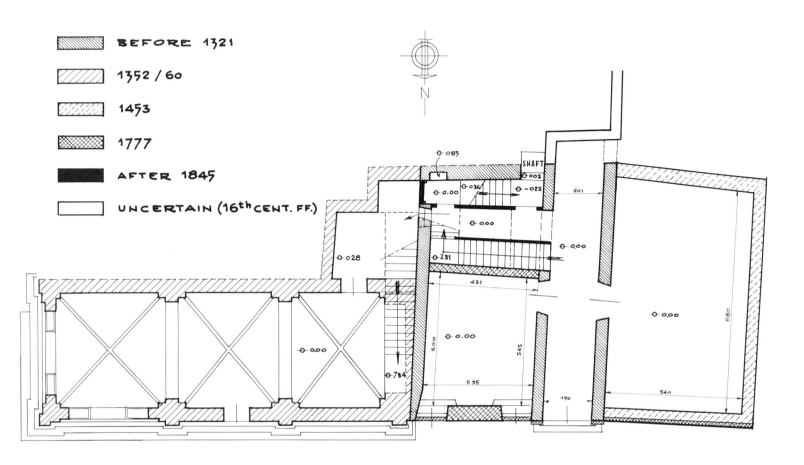

BEFORE 1321

1352 / 60

1453

1777

AFTER 1845

UNCERTAIN (16ᵗʰ CENT. FF.)

iii. Bigallo, oratory and residence, plan of ground floor, 1965

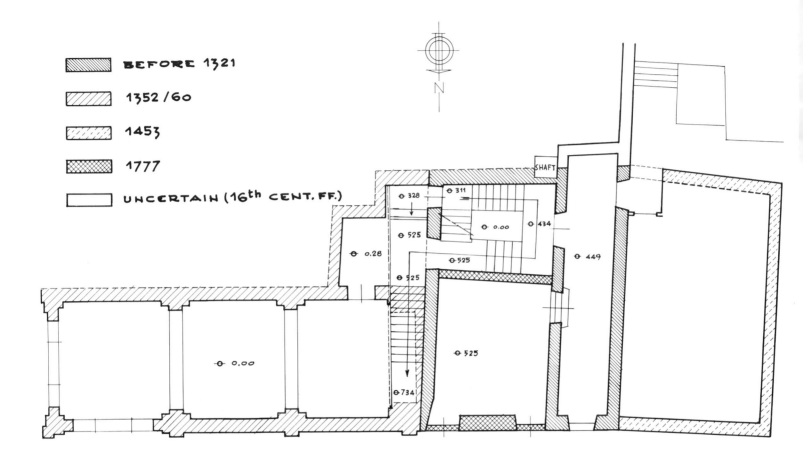

BEFORE 1321

1352/60

1453

1777

UNCERTAIN (16th CENT. FF.)

N

SHAFT

⊕ 328
⊕ 311
⊕ 0.00
⊕ 434
⊕ 525
⊕ 0.28
⊕ 449
⊕ 525
⊕ 525
⊕ 0.00
⊕ 525
⊕ 734

0 5 10 m.

iv. Bigallo, oratory and residence, plan of first floor (piano nobile), 1965

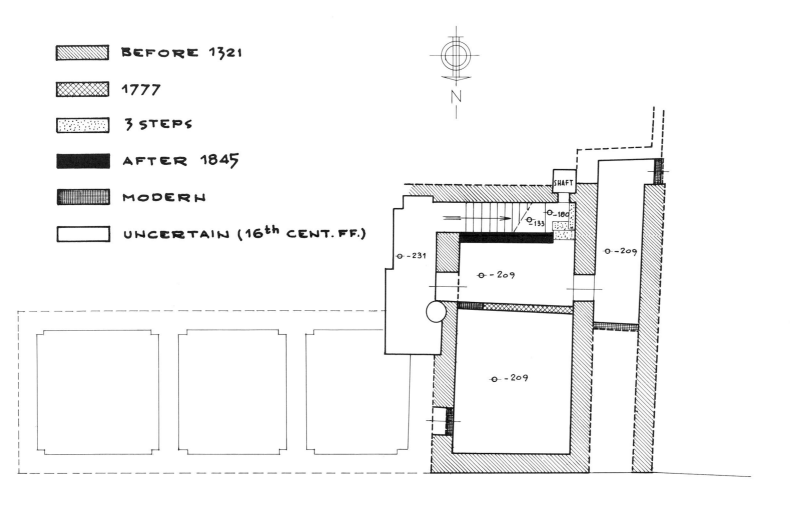

BEFORE 1321

1777

3 STEPS

AFTER 1845

MODERN

UNCERTAIN (16th CENT. FF.)

N

SHAFT

−231

−209

−133

−180

−209

−209

0 5 10 m.

v. Bigallo, "old" residence, plan of cellar, 1965

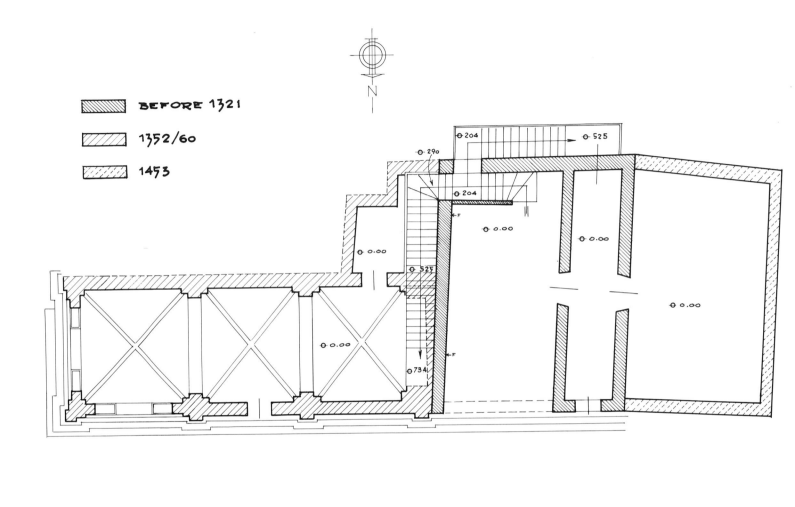

N

BEFORE 1321

1352/60

1453

0 5 10 m.

vi. Bigallo, reconstruction of plan of oratory and residence ground floor.
State before 1777 (without post-XV cent. additions)

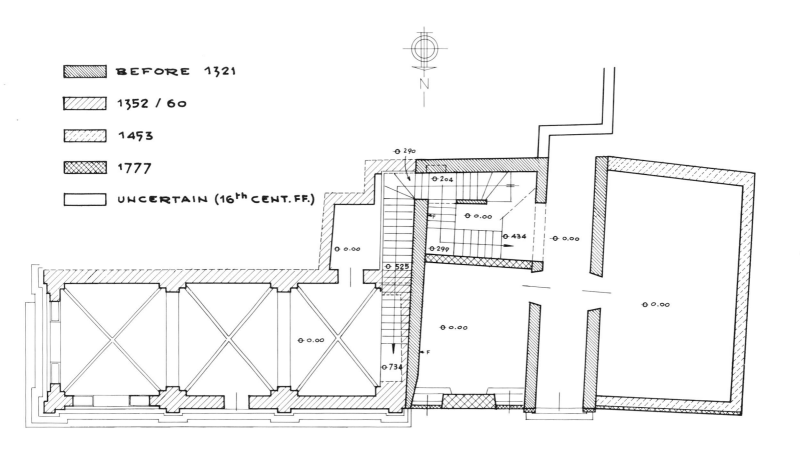

BEFORE 1321

1352 / 60

1453

1777

UNCERTAIN (16ᵗʰ CENT. FF.)

N

⊖ 290
⊖ 204
F
⊖ 0.00
⊖ 434
⊖ 0.00
⊖ 0.00
⊖ 299
⊖ 0.00
⊖ 525
⊖ 0.00
⊖ 0.00
F
⊖ 0.00
⊖ 734

0 5 10 m.

vii. Bigallo, reconstruction of plan of oratory and residence ground floor.
State after 1777 (before XIX cent. rearrangement)

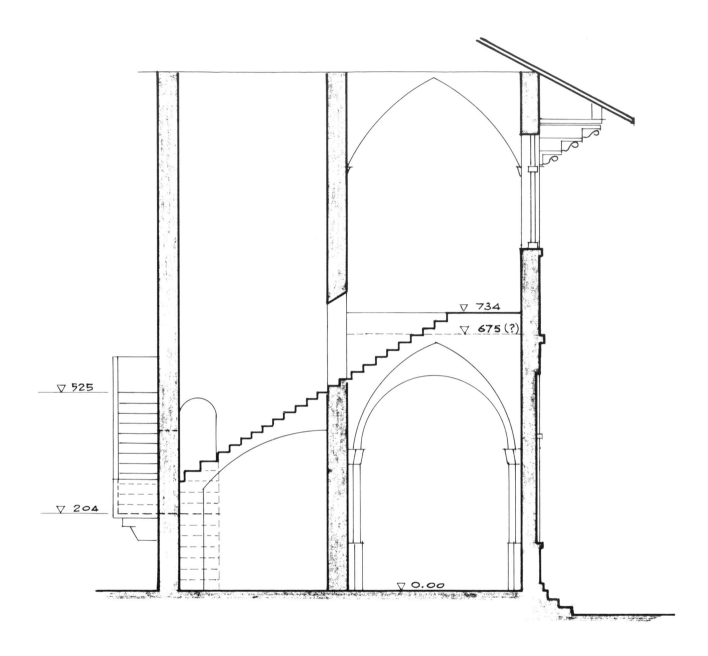

▽ 734

▽ 675 (?)

▽ 525

▽ 204

▽ 0.00

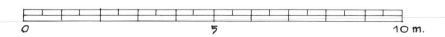

0 5 10 m.

viii. Bigallo, reconstruction of stairway arrangement before 1777

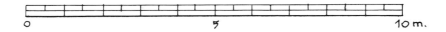

0 5 10 m.

ix. Bigallo, reconstruction of stairway arrangement after 1777

▽ 734

▽ 0.00

▽ -231

0 5 10 m.

x. Bigallo, present stairway arrangement, 1965

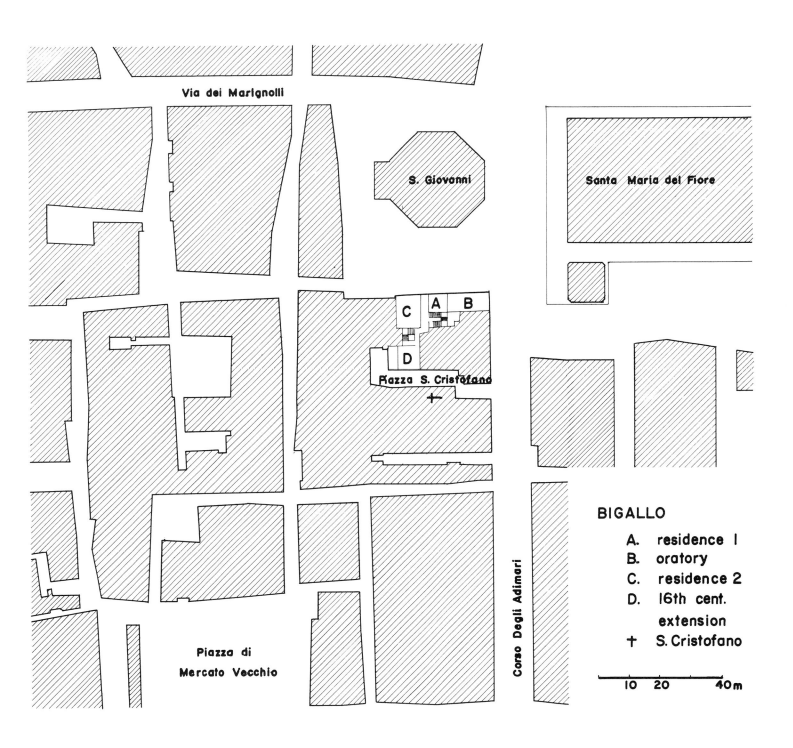

Via dei Marignolli

S. Giovanni

Santa Maria del Fiore

C A B

D

Piazza S. Cristofano

Piazza di
Mercato Vecchio

Corso Degli Adimari

BIGALLO

A. residence 1
B. oratory
C. residence 2
D. 16th cent.
 extension
+ S. Cristofano

10 20 40 m

xi. Florence, old center before demolition, detail with Bigallo at top right

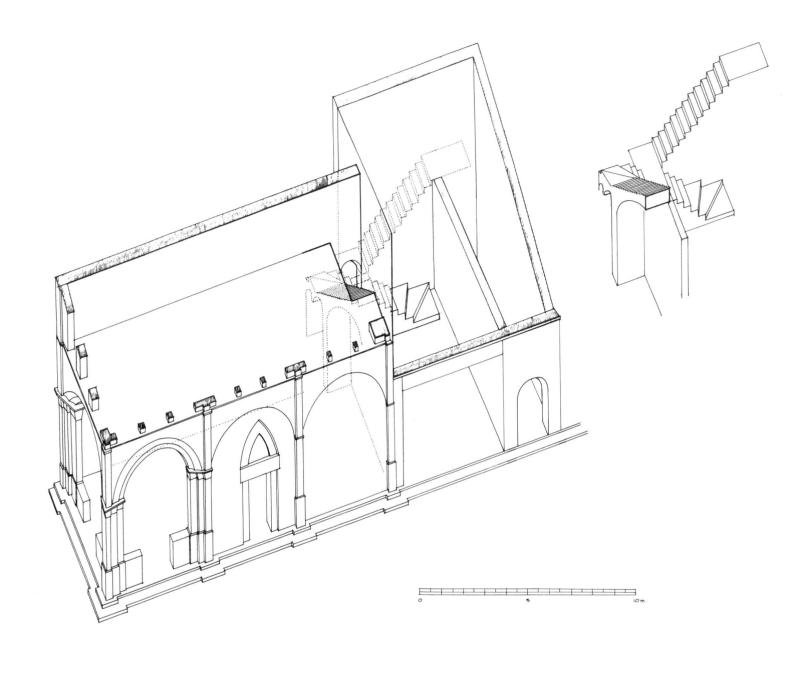

xii. Bigallo, isometric reconstruction of oratory and residence.
State before 1442

List of Illustrations

The Bigallo

The Oratory and Residence of

the Compagnia del Bigallo

e della Misericordia in Florence

1

From Misericordia to Bigallo

The efficient administration of various civic enterprises in fourteenth and fifteenth century Florence rested in part on a system by which the Signoria delegated its control to one of the major guilds.[1] The key decision-making posts were filled by chosen guild members, who served without pay for periods ranging from four to six months. The administrative personnel was salaried and usually hired on an annual basis. Voluminous records of deliberations, appropriations, income, and expenditures were kept. Where the books are preserved, they serve as a major source of information concerning these activities.

Since the administration of the guilds and of the enterprises delegated to them was modeled on that of the Florentine Republic itself, the architectural framework in which these functions were carried out likewise resembled the seat of Florentine governmental power, the Palazzo della Signoria.[2] Thus the various

1. A. Doren, *Das Florentiner Zunftwesen*, Stuttgart-Berlin, 1908, 702ff. See also Doren, "Das Aktenbuch für Ghibertis Matthäus-Statue an Or San Michele zu Florenz," in *Italienische Forschungen*, I, 1906, 7–9; and R. and T. Krautheimer, *Lorenzo Ghiberti*, Princeton, 1956, 32ff.

2. There is no definitive architectural study of the Palazzo Vecchio. A. Lensi, *Palazzo Vecchio*, Milan-Rome, 1929, makes lively reading, but leaves open numerous questions regarding the building history. For reference to unpublished documents concerning the Dogana, cf. H. Saalman,

residenze of the guilds and their subordinate agencies have audience chambers for the meetings of the executive officials, *scriptoria* for the notary and the archives, smaller rooms for related functions (*guardarobe, necessaria,* kitchens, cellars, etc.), and, sometimes, a courtyard containing a well. In addition there is generally a *sala grande,* usually on an upper floor, for meetings of the larger administrative bodies and for the annual celebrations on the feast days of patron saints, as well as a chapel for religious observances.[3]

Specific building and maintenance jobs, such as those at the churches of Santa Maria del Fiore, San Giovanni, Santa Croce, and San Miniato, were generally assigned to the supervision of a single guild. Other tasks, however, were done under the supervision of two or more guilds or of extra-guild organizations. For instance, the *zecca,* the mint, was under the aegis of the two major guilds which were most urgently concerned with the maintenance of currency standards: the Arte del Cambio, a guild of bankers, and the Arte di Calimala, a guild of wholesale importers-exporters.[4]

Public social services—such as hospital building and administration, provision of hospices for the homeless poor, care of illegitimate, abandoned, or lost children and orphans, ambulance and burial duties—were initially the concern of cloisters and wealthy philanthropists. By the end of the thirteenth century these functions had in many cases been taken over by semi-public religious societies and were financed in large part by legacies of cash and real estate.[5] In the early fourteenth century these organizations were included within the framework of public supervision, understandably so in view of the considerable properties to be administered and the political patronage implicit in such "anti-poverty" efforts. The deliberative and executive organiza-

"The Palazzo Comunale in Montepulciano," *ZfK,* XXVIII, 1965, 32 n. 15. See also D. Marzi, *La Cancelleria fiorentina,* Rocca S. Casciano, 1910, ch. XII.

3. See also the brief remarks in Doren, *Florentiner Zunftwesen,* 435–36, and Archivio di Stato, Florence, *Bigallo* 726, c. 166r,

September 8, 1416 (for a description of the Bigallo archives see the introduction to the Documents, pp. 43–44).

4. Ignazio Orsini, *Storia delle Monete della Repubblica fiorentina,* Florence, 1760.

5. R. Davidsohn, *Geschichte von Florenz,* IV, pt. 2, Berlin, 1927, 46ff.

tion of the societies was tailored along the lines of town and guild administration.[6]

Among these societies, two in particular played an important role in Florentine public life: the Compagnia Maggiore di Santa Maria del Bigallo, which according to tradition was founded by St. Peter Martyr in 1244 (and continues to function, though in altered form) and which was in charge of numerous hospices for the indigent and homeless poor, including the Spedale di Santa Maria alle Fonti, nicknamed "del Bigallo," from which the company took its name;[7] and the Compagnia Maggiore di Santa Maria della Misericordia, of somewhat uncertain origins, which was concerned with the transport of the sick, the burial of the dead, and the care of orphans.[8]

Poor, possibly fraudulent, administration of the company property (mostly real estate) had reduced the Bigallo society to near bankruptcy in the second decade of the fifteenth century. A reform promulgated by the Signoria in 1417 stipulated that in the future major decisions concerning the company—election of officers, *spedalinghi*, disposal of property, etc.—were no longer to

6. Ugo Morini, *Documenti inediti o poco noti per la storia della Misericordia di Firenze (1240–1525)*, Florence, 1940, 2f., doc. II; see also 30, doc. X; 35, doc. XII.

7. L. Passerini, *Storia dei stabilimenti di Beneficienza . . . della città di Firenze*, Florence, 1853, 1–60.

8. According to St. Antoninus (cf. Passerini, *ibid.*, 446f., and W. and E. Paatz, *Die Kirchen von Florenz*, I, Frankfurt a. M., 1940, 386 n. 4), the Misericordia had its origins in the Laudesi Brotherhood of Or San Michele, founded in 1292. Davidsohn (*Geschichte*, IV, pt. 3, 55) has another version, according to which the Misericordia company grew out of the so-called Spedale dei Portatori in Via San Gallo. Both versions may have some basis in fact. Related to this version is the popular account current in the 17th–18th century according to which the Misericordia had its origins in a cellar under the later Residence. Pietro di Luca Borsi and his gambling and swearing *facchini* decided one day (the dates vary from 1240 to 1409) to put a coin into a bag for every oath uttered. The money was used to found the Misericordia and the carriers began collecting the sick and burying the dead. On January 3rd (or 13th) 1425 they put out a painting with a picture of *Cristo Morto* with a box in front of it. The proceeds, 500 fl., were used to buy the loggia and erect an oratory in it. In 1425 (or 1432) Archbishop Giovanni Vitelleschi consecrated it and Eugene IV later granted indulgences to pious contributors. This report, interesting for the precise and wholly fictitious dates with which the mythical story is elaborated was published by Richa (*Chiese Fiorentine*, VII, Florence, 1758, p. 244f.) and by Landini, *op. cit.*, p. xxv f. Vitelleschi did not become archbishop until 1435.

be made at the discretion of the *capitani* alone. A group of twenty-two *arroti*,[9] including delegates from the Parte Guelfa, the Six of the Mercanzia, all of the major and four of the minor guilds, was to meet with the eight *capitani* at least once a year to make these decisions.[10]

The influence of Cosimo di Giovanni de' Medici, Bigallo treasurer in the mid-1420's, induced the Signoria to provide for the merger of the Bigallo company with the more affluent Misericordia in 1425. The merger statute provided for, among other things, progressive reduction of the *capitani* to four members from each body, and joint residence of the *capitani* of both companies in the seat of the Misericordia on Piazza San Giovanni.[11] The *provvisione* of 1417 continued to be binding for the merged companies after 1425.[12] This last point is important because the newly instituted periodic sessions, comprising at least thirty persons plus a notary and assistants, made unforeseen demands on the available meeting space in the Misericordia residence.

In theory both companies were to continue their traditional functions under joint administration, but subsequent events make it clear that the Bigallo interests were dominant in the merged body. While the care of orphans and the endowment of deserving girls continued to be a concern of the joint company after 1425, the available funds, largely derived from rentals of the company real estate, were spent mostly on the building, maintenance, and administration of the various *spedali* or hospices under the Bigallo aegis.[13] A salaried *capomaestro*, employed in the building and maintenance of the hospices as well as the com-

9. For a precise definition of the term "arroti" and the functions of the special committee members, cf. Doren, "Ghibertis Matthäus-Statue," 20 n. 3.

10. The *provvisione* of May 26, 1417, is published in Passerini, *Storia dei stabilimenti*, 793–96.

11. The merger statute of October 23, 1425, is published in Passerini, *ibid.*, 796–98. Cf. also Morini, *Documenti*, XIX, 46.

12. The first large meeting under this provision took place on December 19, 1425 (see Doc. 8b).

13. For a list of the hospices under Bigallo-Misericordia administration in 1428–29, see Doc. 19b.

The building and land of the Spedale di Santa Lucia de' Magnoli in Via de' Bardi were sold to Ilarione and Andrea di Lipaccio de' Bardi in 1427 (*Bigallo* v, 1, c. 41v, 64r–66r; cf. H. Saalman, "Tommaso Spinelli, Michelozzo, Manetti and Rossellino," JSAH, XXV, 1966, p. 161, n. 43, doc. 5). A new hospice of Santa Lucia was begun near the Porta San Frediano in 1429 and completed around 1435 (*Bigallo* v, 2, c. 6v).

pany houses, was on the Bigallo payroll before 1426 and continued as a regular fixture in the establishment after the merger.[14] The cult of St. Tobias, the patron of the Misericordia, while not abandoned, became more and more subordinated to that of Saints Peter Martyr and Lucy, the Bigallo patrons,[15] and the *capitani* took every further occasion to impose visible signs of the Bigallo saints on the old Misericordia residence. The burial of indigent dead, a traditional function of the Misericordia, ceased.[16]

The following study of the Misericordia residence and its oratory (Fig. 1) is prompted not only by the inherent interest of the buildings themselves, but particularly by the fact that few such administrative complexes have survived the demolitions of the old center of Florence at the end of the nineteenth century. Moreover, those that have survived are, for the most part, contrary to common opinion, creations not of the thirteenth or fourteenth centuries, but of the fifteenth, replacing older more modest quarters. The Zecca, for example, together with the nearby guild hall of the Arte de' Vaiai e Pelliciai (tanners)—now part of the Uffizi complex—is, though contained in fourteenth century walls, essentially the product of a transformation effected in the second half of the 1420's, or possibly even later.[17] The Palazzo di Parte Guelfa and the adjacent residence of the Arte della Seta were, with the exception of an older block facing Via delle Terme and Piazza di San Biagio, wholly built in the 1420's and after.[18] The residence of the Arte de' Beccai (butchers) facing Or San Michele (Fig. 2), which survived the demolitions of the center and has so far escaped "restoration," appears to this writer wholly a product of the period after about 1415–1420.[19] The residence

14. See, for example, Doc. 12a. The Misericordia company also hired masters as needed before the merger, but appears to have had no permanent *capomaestro* (cf. *Bigallo* II, 3, c. 94r, December 4, 1393).

15. The amounts spent in celebrating the feast of St. Peter Martyr were generally three to four times higher than those spent on the feast of St. Tobias. See, for example, *Bigallo* v, 3, cc. 14v, 17r, 40r, 41v.

16. See Morini, *Documenti*, 58f., docs. 22–23.

17. H. Saalman, "Michelozzo Studies: The Florentine Mint," *Festschrift Ulrich Middeldorf*, Berlin, 1968, pp. 140–142. See also U. Dorini, "Le Case dei Pulci," *Bullettino dell'Associazione per la Difesa di Firenze antica, Supplemento al quinto fascicolo*, Florence, 1906, 7f., plan facing pp. 12–13.

18. Saalman, "Palazzo Comunale," 44.

19. In the 1429 *catasto* of the Arte de' Beccai (Arch. di Stato, Florence, *Catasto* 291, c. 53v) this guild house is de-

of the Tribunal of the Mercanzia in Piazza della Signoria, a conglomeration of several buildings, much tampered with, remains practically unstudied.[20] The house of the Arte della Lana (wool guild) opposite Or San Michele, also much retouched, is an almost lone survivor from the Trecento.[21] Under these circumstances the Misericordia-Bigallo complex, dating from the early and middle fourteenth century with some significant fifteenth century alterations and later modifications, has not received the close attention it deserves.

scribed as "con androne dinanzi." Since the present house (Fig. 2) has nothing resembling an "androne" in front or back, this might be taken as an indication that the house postdates 1429.

20. W. Limburger, *Die Gebäude von Florenz*, Leipzig, 1910, 112, No. 459.

21. *Ibid.*, 85f., No. 369; G. Carocci, *Il Mercato vecchio di Firenze*, Florence, 1884, 136f. The decision to rebuild (or restore) the residence after damages incurred during the Ciompi riots was made on June 4, 1394 (Arch. di Stato, Florence, *Arte della Lana* 47, cc. 104v–105r). I owe this last reference to my colleague Prof. Gene Brucker, Berkeley, Calif.

2

Oratory, Residence, and Frescoes

In 1853 the tireless Luigi Passerini wrote the first documented history of the residence and oratory of the Misericordia-Bigallo company as part of his studies of Florentine beneficent institutions.[22] Giovanni Poggi and more recently Ugo Morini added further documents.[23] Nonetheless, the history of these buildings and of the various frescoes that decorate their interior and exterior continues to lead to misunderstandings in the literature. One persistent source of confusion is the tendency to treat the oratory and residence as if they were a single unit,[24] which is not the

22. Passerini, *Storia dei stabilimenti*, 1–60, 440–57.

23. G. Poggi, "La Compagnia del Bigallo," *RivdA*, II, 1904, 189f.; Morini, *Documenti.*

24. This has led Paatz (*Kirchen*, I, 390 nn. 34–35) to date the well known *Misericordia* fresco in 1352 (contrary to the inscription 1342), on the apparent assumption that the residence containing the

udienza (on the wall of which the fresco is painted) was built in 1352 and after, together with the oratory. Similarly G. and C. Thiem, *Toskanische Fassaden-Dekoration*, Munich, 1964, 135f. Passerini (p. 452), who did not know the Strozzi excerpt concerning the 1321–22 purchase of the house (see Doc. 1), nevertheless suspected that the residence must be older than the oratory, precisely because of the date on

case. According to a document published by Poggi (Doc. 1), the house next to the oratory, described as "la casa dirimpetto alla porta del Battesimo di S. Giovanni," was purchased in 1321, (Text Fig. xi, A).[25] The adjoining corner plot with a then existing house on it (Text Fig. xi, B), did not come into the possession of the company until 1351 (Doc. 2). In January, 1352, with the corner house apparently demolished, a new oratory was laid out on the corner plot (Doc. 3). In 1358 the grillwork enclosing the open corner loggia was paid for, but the building was not finished at that time as Poggi and Paatz imply,[26] because in December, 1359, the vaults and "altro lavorio che intorno accio bisogna di fare" were still undone (Doc. 4). The vaults, upper parts, and roof were completed in 1360–1361 (Doc. 5, 6). By 1364 a certain Nardo, perhaps Nardo di Cione, brother of Orcagna, had painted the vaults and Alberto Arnoldi had completed the Madonna and angels for the oratory altar.[27]

In 1386 Niccolo di Piero Gerini and Ambrogio di Baldese painted a fresco on the "faccia dinanzi della casa della Misericordia" depicting the captains of the Misericordia returning lost children to their mothers (Doc. 7). The scene of the action is the oratory. A fragment of this fresco has survived in the old *udienza* of the residence next to the oratory (Figs. 5, 10–12), and its original

the fresco. Cf. also H. Saalman, "Santa Maria del Fiore: 1294–1418," *AB*, XLVI, 1964, 472, n. 6.

25. Poggi, "Bigallo," 194 n. 1. The earliest record of a meeting "in domo soc(ietatis) mis(ericordiae)" dates from 1349 (*Bigallo* II, 1, c. 2r).

26. Poggi, "Bigallo," 194; Paatz, *Kirchen*, I, 379. Passerini's more cautious "pressochè compita" is acceptable (*Storia dei stabilimenti*, 453).

27. Paatz, *Kirchen*, I, 383. Speculation concerning the architect of the oratory has run the gamut from Nicola Pisano (Vasari), to Arnolfo di Cambio (K. Frey), Alberto Arnoldi (Frey again, and Poggi), and Orcagna (Passerini). Francesco Talenti, directing the work on the campanile across the street in these years, might be added to the list. Technically the job was such that any of the masters working at the Duomo in these years (Talenti, Arnoldi, Orcagna, Neri di Fioravante, Benci di Cione, *et al.*) could have directed the operation. The character of the sculptural details of the loggia is not individual enough to identify any of the known masters with them. The fact that Arnoldi did the figures for the altar after 1359 makes one suspect him as *capomaestro* in the years before. But the same reasoning could be applied in naming Orcagna, since his brother Nardo di Cione may have painted in the oratory as he did at Or San Michele, where Orcagna was *archimagister* in these years. Perhaps it might be best to attribute the little building and its relief decoration to the ubiquitous *opera* of Santa Maria del Fiore as a whole.

aspect is preserved in a watercolor copy made before the fresco was mutilated in the eighteenth century (Fig. 6). A comparison of the copy with the surviving fragment of the fresco suggests that the parts of the original now lost are faithfully reproduced in the copy. The question of the former location of this fresco has created some misunderstandings.[28] However, later reports and the 1777 inscription under the fresco fragment[29] leave no doubt that this fresco was formerly on the façade of the residence, *not* the oratory.

A puzzling fact points the way to further inquiry. The oratory depicted in the Gerini-Baldese fresco (Fig. 6) is quite different in aspect from the present building (Fig. 1) in an important respect: the present upper story is missing! Instead, each mezzanine bay facing the Baptistery has three small bifora windows, with two windows in the bay facing the campanile. A shallow frieze-like zone with just a trace of a projecting roof (visible at the extreme left) tops the building.

It may be argued that Gerini typically tended toward the fanciful in his architectural backgrounds,[30] but in this case the intention was evidently to depict a specific building: one, moreover, directly adjacent and subject to immediate comparison. While the details are somewhat simplified and the proportions distorted, the Gerini fresco includes all essential elements of the three bays of the lower story and mezzanine of the oratory. Is it possible that this sole surviving fourteenth century view—albeit a copy—errs totally in the upper parts?

Numerous answers to this question could be suggested. One of them is that the 1386 fresco actually depicts the building as it was at that time. Text Figs. i and xii show an attempted restoration of the early state based on the Gerini fresco. Five assumptions about the earlier state are implicit in this restoration:

28. While Poggi seems to have understood where this fresco was located originally, his ambiguous description ("Bigallo," 209) led Paatz (*Kirchen*, i, 390 n. 38; and also Thiem, *Tosk. Fassaden-Dekoration*, 135) to suggest that it may have been in the mezzanine bay over the loggia facing the campanile of Santa Maria del Fiore.

29. Inscription cited in Doc. 22. See also Poggi, "Bigallo," 208, and the descriptions of the fresco in L. del Migliore, *Firenze Città nobilissima*, Florence, 1684, 80; G. Richa, *Notizie istoriche delle Chiese fiorentine*, vii, Florence, 1758, 293; and Passerini, *Storia dei stabilimenti*, 13, 456.

30. R. van Marle, *Italian Schools of Painting*, iii, The Hague, 1924, figs. 348, 350.

(1) that the floor level of the earlier upper story was .59m lower than the present level (7.34m), running at 6.75m, just over the apex (at 6.60m) of the oratory vaults below;

(2) that the windows rose from the floor level at 6.75m, equivalent to the lower line of the present exterior mezzanine story;

(3) that the former window story had the height of the present mezzanine;

(4) that the frieze zone over the windows shown in the fresco was roughly one-half as high as the window zone;

(5) that the upper story was not vaulted as it is now, but was covered with a ceiling or with an open roof.

The existing mezzanine story is 2.08m high, topped by a 22cm-high cornice. Giving half of the mezzanine dimension, or 1.04m to the frieze zone would result in an interior space 3.12m high— not lofty, but adequate. An open roof would have added further height.

While we find ourselves entering the realm of speculation with these assumptions, this reconstruction has the virtue of a compatible interior-exterior system and may indeed represent the original state prior to later alterations.

The next existing view of the Misericordia complex is in the codex of Bartolommeo Rustici (or Rustichi), datable around 1448–1450 [31] (Fig. 7). There are here actually two adjacent drawings, an overall view (Rustici B) and a detail (Rustici A). Rustici B shows the oratory more or less as it is now, *with* the upper story, but *without* the statues of the Virgin and Child and Saints Peter Martyr and Lucy, now in the easternmost mezzanine bay over the loggia, and without trace of the scenes from the life of St. Peter Martyr in the two adjoining mezzanine bays to the west. Instead the mezzanine bays are each divided in half by stone or painted pilaster strips with each smaller space decorated by a diamond-shaped ornament. Assuming that the Gerini fresco gives us a reliable view of the oratory as it was in 1386, the present

31. A number of miniatures in the codex, including the Bigallo view, are reproduced (with distorting retouches) in A. Sapori, *Compagnie e Mercanti di Firenze antica,* Florence, 1955, with comments by Ugo Procacci. The miniatures in the codex appear to be based on drawings made some years before the codex itself was written and illustrated in 1448f.

upper story must have been created between this date and the time the Rustici miniature (or the drawing on which it was based) was made, that is, some time before 1450. We shall return to this question below.

The view of the adjacent residence shown in the Rustici codex is as interesting as the oratory. In place of the present unified façade dating from the reconstruction after 1777 (Fig. 1; cf. Chapter 5), there are two contiguous buildings, the one on the left somewhat wider than the one on the right. The ground floor of the building adjoining the oratory comprises a *bottega*-like room open toward the front. The "bottega" and a portal to its right are accessible by a flight of four steps running up from the then somewhat lower level of the piazza. The upper limit of the opening appears to be slightly below the springing points (at 4.11m) of the adjacent oratory arcades. Over it, on an area of wall extending a little above the lower line of the mezzanine story, are indications of two zones of figured painting, extending across the width of the building.[32] Above this follow three wide windows with flat arches, two over the *bottega* and one over the portal, and then the roof, considerably below the roof of the oratory.

That this depiction is no quirk in the imagination of the illustrator of the Rustici codex is demonstrated by the 1515 predella panel by Ridolfo Ghirlandaio on the oratory altar (Fig. 8). While Ghirlandaio's apparent realism is marred by the curious fact that the western bay of the oratory is omitted (for reasons of scale?), the adjoining house has the same open ground floor room, the two zones of figured painting above, and the windows. The right-hand and upper parts of the building are outside the limits of the panel.

The *bottega*, evidently the frequently documented *udienza* (see pp. 14f. below), is shown in greater detail in a particular

32. The approximate original dimensions of the Gerini-Baldese fresco formerly on this façade can be reconstructed by comparing the existing fragment with the 18th-century aquarelle (Figs. 5, 6). The fragment measures 2.57 × 1.005m. Its original dimension was calculated to be approximately 4.64 × 1.37m. Accordingly, the fresco could not have extended across the whole width of the old residence façade (ca. 7.77m) but only over the section over the *bottega* (*udienza;* see p. 14 below). This accords with Rustici A (Fig. 7), in which a line divides the wall over the *bottega* from the part over the adjoining corridor.

(Rustici A) just above the overall view (Rustici B) and is labeled "lamisericordia." The room has a door in its western wall, leading into the corridor behind the façade portal to the right of the *udienza*. At the rear of the room an open flight of stairs rises upward toward the left, apparently the means of access to the upper levels (cf. Chapters 5–6 below). The detail differs from the general view in one important respect: the pictorial decoration on the wall over the *udienza* is omitted, and there is space only for the lower fresco zone. In place of the upper zone there are what appear to be the lower parts of four barred windows, three over the *udienza*, one over the corridor. Above this the detail is cut off by a line.

In neither the Rustici nor the Ghirlandaio view is there a trace of the *Misericordia* fresco, still extant over the right-hand door of the former *udienza* (Figs. 11, 13) and the most important single work of art in the residence.[33] The twelve surviving scenes of a former cycle of eighteen from the life of Tobias (the Misericordia patron saint), which were almost certainly painted on the eastern wall of the *udienza* (Fig. 10) before the 1425 merger,[34] are not in the line of vision.

Documents, mostly unpublished, from the Bigallo archives shed new light on the questions raised by the Gerini and Rustici views. A first problem to be examined concerns the various meeting rooms mentioned in the documents and their location in the Misericordia-Bigallo residence. The ordinary meeting place of the *capitani*, both before and after the merger, was the *udienza*.[35] That the *udienza* was the *bottega* of the Rustici miniature and that there was a larger upper meeting room as well is demonstrated by a document of December 9, 1452, published in excerpts by Poggi (Doc. 16a). The captains complain that their

33. Concerning the date of this fresco and its significance for the history of the cathedral, cf. H. Saalman, "Santa Maria del Fiore," 472 n. 6.

34. Cf. Paatz, *Kirchen*, I, 383.

35. The lengthy legal formula with which any account of a formal meeting begins in 14th and 15th century documents inevitably includes a reference to the place of meeting. While this reference is often rather general, it may also be more specific, particularly if a "residence" has various rooms of different dimensions for larger and smaller gatherings.

"audientia est tam nimis parva et misera quod quando ipsi con-
gregare volunt (i.e., with a larger number of *arroti*) necesse est
exire de ipsa et ire et se congregare in sala superioris . . ." As we
have noted, the reform provision of 1417 required that these larger
meetings with invited delegates take place once or twice a year.
The reports prior to 1452 regularly locate the meetings "i(n)
sala mag(n)a domus residentie dicte sotietatis," or more specifi-
cally "in dom(um) Residentie d(i)c(t)or(um) Capitaneoru(m) et
in sala sup(er)iorj magna dicti domus ubi p(er)factis et negocijs
dicte societatis soliti su(n)t choadunatj" (Docs. 8c, f), but without
defining either *domus* or *residentie* more precisely.[36]

Further definition of these terms is provided in other docu-
ments. On October 15, 1427 (Doc. 9a), the captains of the newly
merged Misericordia-Bigallo company decided that the duties
of chaplain and sacristan of the oratory should henceforth be com-
bined in the person of a priest who would have permanent resi-
dence in the company buildings. On October 31 of the same year
(Doc. 9b) the annual salary of the chaplain to be elected was
fixed at twenty florins, with the further provision "et et(iam)
ha(b)eat ha(b)ita(tionem) domu(m) posit(um) sup(er) d(ict)um
oratoriu(m) et ubj d(omi)nj cap(itanj) residentia(m) faciu(n)t."
That this *habitatione* had yet to be created in the *domus* over the
oratory is confirmed by payments to various sources on March 16,
1428 (stile comune),[37] for labor and materials "p(ro) laborerio
ha(b)itatio(n)is chappellanj oratorij misericordie" (Doc. 9c).
The job must have been completed by the end of May, 1428, when
a certain Mariano *charettaio*[38] was paid "p(er) disgombrando
plateam s(anct)j xr(ist)ofanj" (Doc. 9d). The little piazza of San
Cristofano, directly behind the Bigallo complex (Text Fig. xi),
had evidently been used for piling up the necessary building ma-

36. That *residentia* and *audientia*
were not necessarily identical, or that the
second may be a specific location within the
first, is revealed by a notary's correction in
a document of December 17, 1427 (*Bigallo*
v, c. 59v): ". . . Capitani Insimul i(n) loco
eor(um) solite residentie . . ." *Residentie*
is crossed out and "audie(n)tie" substi-
tuted. But cf. *Bigallo* VI, 7, c. 5: "in loco
eorum solite residentie et audientie . . ."

37. For an explanation of *stile comune*
(s.c.) see the introduction to the Docu-
ments, p. 44 below.

38. A "Mariano carrettaio" appears
in a document of 1421 in the Arte del Cambio
account book concerned with Ghiberti's
St. Matthew for Or San Michele; cf. Doren,
"Matthäus-Statue," 33.

terial, leaving the Piazza San Giovanni unencumbered.[39] The new chaplain was forthwith elected and eventually reelected with re-affirmation of his right to residence in the *domus* (Docs. 9b, e).

It appears that the *sala magna superiore* is identical with the *domus* over the oratory and that, in one form or another, this *sala magna* existed at least as early as December 19, 1425, the first time it is mentioned.[40] Less certain is the nature and extent of the alterations to which the *domus . . . super . . . oratorium* was subjected in early 1428. The sums expended are relatively small, amounting to less than sixty lire. Since documents after 1428 repeatedly refer to the "camera del sagrestano" and the "sala del sagrestano" as distinct entities,[41] and since at least part of the *domus* was to continue to serve as a place "ubj d(omi)nj cap(itanj) residentia(m) faciu(n)t," it appears that the alterations of 1428 were limited to dividing off the bay over the loggia from the rest

39. The topographical situation around the Bigallo (Text Fig. 11) can be reconstructed from scattered elements. On November 22, 1441 (*Bigallo* VI, 1, c. 33r), the shop in the house adjacent to the old *udienza* (the later new *udienza;* Doc. 16a) was rented out and described as "juxta audientia et seu residentia dic(t)or(um) cap-itaneo(rum) super platea(m) s. Johan(n)is in suos confines . . ." The extent of the property is given in the context of a subsequent lease of the shop (*Bigallo* VI, 1, c. 34v, June 20, 1442): "1° dicta platea 2° *bona de societatis* 3° platea s. cristofanj 4° bona dicte societatis." In his *catasto* of 1427 a certain Ser Jacopo di Bonaiuto Landi, Bigallo notary (Arch. di Stato, Florence, *Catasto* 54 [1427], c. 44v) described his house as "una casa posta Insulla piazza di. S. Giovan(n)j allato allamise-ricordia che dap(ri)mo Lapiazza di S. Gio-van(n)j a s(econd)o Lamisericordia a te(r)zo La piazuola di S. xr(ist)ofano aiiij E benj della chiesa dj s. salvadorc dj firenze." If Landi's house was next door to the property cited in the 1442 lease, the company must have acquired it before 1442, since the 1442 lease lists society property on either side of the future new *udienza* site. Of course, it may have been still one door farther to the west.

The Piazza of San Cristofano evidently extended behind all three of these houses. Whether the "atrio" behind the old residence was merely an extension of this piazza or divided from it by a wall is uncertain. The piazza (the present Piazza degli Adimari) has been reduced by 19th century construction, but it still extends to behind the second house west of the old residence (cf. *Stradario storico ed amministrativo della Città e del Comune di Firenze*, Florence, 1929, 1). The old church of San Cristofano has disappeared or has been absorbed into the fabric of the out-patient clinic and ambulance garage connected with the present-day Misericordia, whose main establishment is just across the street from the old Misericordia at the corner of the Via del Calzaiuolo (old Corso degli Adimari) and Piazza del Duomo. Cf. Paatz, *Kirchen*, I, 492ff.

40. It is also clear that the terms "domus" and "residentia" were applied ambiguously to the upper part of the oratory as well as to the adjoining building containing the *udienza.*

41. *Bigallo* 1668 (inventory of objects in the sacristy, *casa,* etc.), cc. 1f (Inventory 1436); c. 24v (Inventory 1573).

of the upper hall and making the room habitable. In 1429 a "scriptoriu(m) Justa audientia(m) . . . in quo existant om(n)es librj et scriptura d(i)c(t)e sotietatis" was added to the residence (see Docs. 10a–d).

The key event in the fifteenth-century history of the Bigallo complex was a fire in July, 1442. Most of the documents concerning this fire are ambiguous (Docs. 12a–e), but a credit to a carpenter in August, 1442, specifies that the woodwork he provided was "p(er) rifare la chasa dela mis(er)ichordia cioe quela de p(re)tte qu(an)do a(r)se" (Docs. 12f, g). There is no doubt, therefore, that the upper part of the oratory burned. Just a day after the fire the *capitani* met and decided that the "domus dictae societatis et eorum residentiae heri combusta" be rebuilt with utmost urgency ("quam citius poterit") (Doc. 12a). The speed with which provisions for the reconstruction were made suggests that if the captains did not actually set the fire themselves, it nevertheless offered them a welcome opportunity for making some long desired alterations and improvements. The reconstruction was completed in the record time of four weeks and the sum spent on materials and labor, over 236 lire, was fairly substantial (Docs. 12b–g). It seems reasonable, therefore, to propose that the upper story of the oratory as it appears in Rustici B and later views and as it exists today (Figs. 1, 7) was created after the fire of 1442. The reconstruction did not recreate the previous state, but represents a substantial enlargement of the upper story. With its high vaults and large bifora windows, the *sala magna* became in fact what it previously had been only in magniloquent name.[42] The work also prepared

42. While all indications point to a substantial enlargement of the upper story in 1442, caution regarding the nature of the interior alterations made at that time is in order. The upper floor underwent radical restoration in 1882 prior to being turned into a museum at the beginning of the present century (cf. Poggi, "Bigallo," 202). As far as I am able to judge, most of the bifora windows and all of the interior stone details, (door frames, vault console capitals; cf. Figs. 3, 17–20) are modern, presumably reproductions of previously existing details. I have not found records of that restoration, but the word "presumably" is spoken with considerable hesitation, in view of the fact that the 1442 documents (Docs. 12c–g) repeatedly refer to the construction of the roof —which, with its impressive brackets (Fig. 1), is one of the major features of the *post-ignem* oratory—but do not refer to vaults. Furthermore, "540 tra quadruccj e matoni" (Doc. 12e), the only bricks mentioned, do not seem sufficient to account for the present vaults. On the other hand, the form of the vault consoles as well as the door frames (if they are, in fact, reproductions of previously existing ones) corresponds to a style which

the ground for an elaborate campaign of decoration of both the oratory and residence, in which the ascendancy of the Bigallo company within the merged society achieved visible expression.

may be identified with a relatively wide group of stonemasons working in the Michelozzo circle in the period ca. 1415–60 (cf. Saalman, "Palazzo Comunale," 1ff.). The documents before 1442 provide no evidence of major alterations in the upper story except for the creation of the priest's apartment in 1427–28 (Doc. 9a–j). The relatively small number of bricks bought in 1442 are not decisive evidence against the construction of the vaults at that time. With a full-time *capomaestro* on the payroll and numerous building and repair projects on houses and hospices belonging to the company constantly under way (cf. note 13 above), the required building materials may have been on hand so that it would not have been necessary to buy them. Furthermore the *capitani* ordered that where possible materials for the repair of the residence should be obtained from debtors of the company (Doc. 12a) and such settlements would not necessarily appear in the company books. Cf. also note 49 below.

The matter has another aspect. The vault of the western bay is supported on the present thin western wall of the *sala* (Fig. 18). This wall, which forms the eastern side of the narrow stairhall adjoining the *sala*, reduces the effective size of the hall by some 1.10m, the width of the stairhall at the present *sala* level. The main reason for its creation appears to lie in the fact that the eastern wall of the adjacent old residence (and the other old residence walls) run at an angle some 7° wide of the perpendicular on the oratory façade. Using the residence wall as the western termination of the vaulted *sala* would have led to a sharply distorted vault in the western bay and made access to the garret over the vaults difficult (cf. note 72 below). The wall east of the stairs resolves the problem, creating a narrow rectangular bay similar to the western bay in the oratory below and leaving a trapezoidal stairhall. It seems probable that the thin wall and the *sala* vaults are contemporary.

The original, pre-1442, *sala* probably —and logically—extended to the residence wall with the stairs entering directly through the floor (Text Fig. xii), as was the case with the original Palazzo Vecchio stairway leading up to the space adjoining the early Sala dei Dugento (cf. A. Lensi's somewhat problematic reconstruction plan; *Palazzo Vecchio*, 4, 295). Just when the floor level was fixed at its present 7.34m also remains uncertain (cf. note 72 below). The wall dividing the upper story into a larger room of two bays and a smaller single bay room at the eastern end, however, appears to correspond to the division into *sala* and *camera di prete* as reported in the documents after 1428.

3

Frescoes, Sculptures, and Problems

The various frescoes and sculptures, surviving or documented, on the exterior façades of the oratory and residence raise a number of problems. We have already discussed the Gerini-Baldese fresco of 1386, which, according to all indications, must originally have been on the wall directly over the opening of the old *udienza*. Also surviving in poor condition are two scenes from the life of St. Peter Martyr, one painted by Ventura di Moro and the other by Rossello and Giunta di Jacopo Franchi in the two western mezzanine bays of the oratory (Doc. 14b; Fig. 1). The painting of these scenes was authorized on March 4, 1445 (s.c.), and completed before August, 1446 (Docs. 14a, b). On March 18, 1445 (s.c.), the three stone figures of the Virgin, St. Peter Martyr, and St. Lucy, formerly on the façade of the ex-residence of the Capitani del Bigallo in the Corso degli Adimari near Or San Michele,[43] were affixed in the mezzanine bay over the oratory loggia (Doc. 15; Fig. 3). Adoring angels were painted in fresco on either side of the Virgin.

43. For the documents, cf. Poggi, "Bigallo," 239ff.

The second document concerning the scenes from the life of St. Peter Martyr refers to "3 storie dipintoci . . . ne la faccia dinanzi della nostra compagnia" (Doc. 14b). Since apparently only two of the *storie* survive, Poggi[44] suggested that the third one may have been intended for the mezzanine bay facing the campanile, whose present decoration he tacitly attributed to Gaetano Bianchi, who repainted the exterior in 1882. Paatz, who wanted to locate the Gerini fresco in that bay,[45] hinted that there was no evidence that the third *storia* was ever executed (although the documents involve payments for, and hence presumably execution of, the paintings!).

But both Rustici B and the Ghirlandaio predella (Figs. 7, 8) show two zones of painting over the open *udienza*. Could it be that the upper fresco zone—painted on what is presumably a new upward extension of the wall expressly created for this purpose during the work carried out after the 1442 fire (cf. below)—represents the *third* now lost *storia?* No figured scene, in any event, ever filled the mezzanine bay facing the campanile. Ghirlandaio's panel which, with the exception of the omitted bay, is nearly photographic in its accuracy, clearly shows the fresco angels flanking the Virgin statue and the figured scene in the adjoining bay, but there is no sign of a painted *storia* in the bay facing the campanile. Another little-known view of the oratory, a pen drawing by Francesco Granacci (Fig. 9),[46] takes some decided liberties with topographical accuracy. Nonetheless, the sketchy indications in the mezzanine bay facing east suggest that Gaetano Bianchi's work (Fig. 4) was based on surviving traces of the original decoration: heads in lozenge-shaped geometrical motifs with a painted pilaster strip in the middle of the bay.[47] This last point is significant.

The discussion is complicated by a series of documents (Docs. 13a–e) concerning painting by Piero Cellini (or Chellini), exe-

44. *Ibid.*, 203.

45. Paatz, *Kirchen,* I 390 nn. 38, 39.

46. Cf. B. Berenson, *The Drawings of the Florentine Painters*, II, Chicago, 1938, 104, No. 982.

47. This is also confirmed by a Giuseppe Zocchi drawing of ca. 1740 (Florence, Museo Topografico, Inv. No. 16645) showing the Baptistery and the Bigallo oratory. See also the Zocchi-Sgrilli print after this drawing entitled "Processione del Corpus Domini," pl. XXI in 1744 series of Florentine *vedute.* Cf. also *Views of Florence and Tuscany by Giuseppe Zocchi,* ed. E. E. Dee, s.l., 1968, pl. 23.

cuted in 1443 and paid for in July, 1444. The documents are frustratingly general in their description of Cellini's work and its precise location ("pro occasione certarum picturarum factarum . . ."). Passerini first divulged a document of July, 1444 (Doc. 13d), according to which Cellini was paid thirty-eight lire "per dipinture a fatto nella facciata dinanzi della chasa nostra quando arse nel anno 1443." But while it is certain that the upper part of the oratory ("chasa . . . de p(re)tte") burned, the documents do not exclude the possibility that the adjacent residence was also affected. Unfortunately, the volume of deliberations of the *capitani* for the year October, 1442–November, 1443 (immediately following the August, 1442 reconstruction), which must have contained the authorization for Cellini's work and perhaps further details, is lost. Judging from the differences between Rustici A and B, it seems at least probable that the wall over the *udienza* was heightened and the windows over it altered in number and size in connection with the restorations after the fire (Text Figs. i, and ii). Thus the position of Cellini's "pictures" is just as uncertain as that of the third Ventura-Rossello *storia*, and their nature remains undefined. The documents confirm, however, that Cellini's work was done and paid for before the three statues were affixed on the oratory on March 18, 1445 (Doc. 15), and before Ventura-Rossello's *storie* had been authorized (Docs. 14a, b). Furthermore, since, according to the views, there never were more than two fresco zones over the *udienza* and since the lower one almost surely contained the Gerini-Baldese fresco, there was room for just *one* more painting.

A first clue toward a tentative solution of the problems raised here is offered by Rustici B (Fig. 7). The view, definitely *post ignem* if our previous conclusions are tenable, shows two zones of painting over the *udienza,* but no trace of either the statues and angels or of the St. Peter Martyr scenes in the adjoining bays of the oratory. Instead each mezzanine bay is filled with two diamond-shaped ornaments divided by a strip. That Rustici B represents a formerly existing situation is confirmed by the fact that the present decoration of the mezzanine bay facing east (Figs. 1, 3)—renewed, as we have noted, but presumably based on surviving traces rather than on the restorer Bianchi's knowledge of the old drawings—is substantially identical with the corresponding elements in the Rustici B view.

Given this observation, the state of the complex shown in Rustici B must antedate March 18, 1445, when the statues were installed, and probably also March 4 of the same year, when the St. Peter Martyr frescoes were authorized. If, furthermore, the difference between Rustici A and B represents an alteration made after the 1442 fire, only Cellini remains in the picture, and he must be connected with the pre-Ventura-Rossello decoration of the oratory as well as with the painting of the newly created upper zone over the *udienza*.

It is somewhat more difficult to account for the fact that the sum of thirty-eight lire (equivalent to about nine florins) paid to Cellini for his work compares poorly with the fifteen florins each credited to the respective accounts of Ventura di Moro and Rossello di Jacopo for their *storie*. Against this fact, however, it must be observed that while Cellini was paid in cash (in silver lire according to Florentine Quattrocento practice in the payment of wages[48]), the generous gold florin award to Ventura and Rossello, based on an estimate by Lorenzo Ghiberti (Doc. 14b), involved nothing more than a bookkeeping operation, since the two painters leased their shops from the Bigallo company and were perpetually in arrears with their rent.[49] No money actually changed hands, and the Bigallo coffers were only indirectly affected.

48. Cf. R. de Roover, *The Rise and Decline of the Medici Bank, 1397–1494*, Cambridge, Mass., 1963, 32.

49. *Bigallo* VI, 2, c. 10r, March 10, 1444 (S.C.); *Bigallo* 746 (1446–47), cc. 7, 10; *Bigallo* V, c. 15r, May 2, 1441: "*Ventura maurj pictor . . . f(iorini) 7 . . . mictas ad speculum.*" The placing of bad debtors *ad speculum* is a frequent procedure of the captains from the 1440's on. This would seem to be the city *speculum* book, in which tax debtors were inscribed, a procedure which eliminated them from the *borsa* as eligible candidates for public office. The *speculum* seems to have had relatively little effect at this time, when public office had lost much of its significance. In accordance with their usual procedure, the Bigallo captains had specified that labor and materials for the reconstruction of the oratory be obtained "*a debitoribus dictae societatis*" (Doc. 12a).

Among those renting houses from the Bigallo-Misericordia company was Lorenzo Ghiberti. He first took the house in Via de' Cenni (present Via de' Panzani) in November, 1425 (Doc. 20a), and kept it until November 1, 1448 (Doc. 20b). The rent due the company was three florins annually. This represents one-third of the total rent, since two-thirds of the house was owned by the brothers of Santa Maria Novella and the Spedale di San Paolo. In 1442 Ghiberti was credited with 15 lire 17 soldi for a chalice, a paten, and "uno i(n)smltto" [smalto?] (Doc. 20d). One Ghiberti entry (Doc. 20c) specifies that the place in Via de' Cenni was the "casa dove elista [egli sta]." What this means is not clear, since Ghiberti repeatedly lists a house he owned in Borgo Allegi as his fam-

The subject of the painting in the upper zone, evidently a figural composition and apparently still visible to Ridolfo Ghirlandaio in 1515 but never mentioned by any of the later commentators, remains a mystery. But if Cellini had already filled the upper zone in 1443–1444, where is (or was) the third Ventura-Rossello *storia?*

All three of the paintings paid for in 1446 (Doc. 14b), are set under the heading "storie . . . di Santo Piero Martire." The word "istoria" is, in the terminology of the period, generally applied to a narrative scene with figures engaged in some kind of action as opposed to an iconic representation such as a Madonna and Child or a Crucifix.[50] In this sense both of the surviving scenes from the life of St. Peter Martyr on the oratory as well as the painted zones formerly on the façade over the *udienza* are "storie." If, however, the two zones on the residence façade can be accounted for by the Gerini-Baldese and Cellini paintings and since there apparently never was any figured *storia* in the bay facing the campanile, it may be tentatively proposed that the third Ventura-Rossello painting consists of the as yet unaccounted-for angels between the tabernacles containing the figures of the Madonna and Sts. Peter Martyr and Lucy (Fig. 3). It should be noted that the authorization of March, 1445 (Doc. 14a), allowed not only for an "Jstoria(m) [*sic*] s(an)c(t)j petrj martiris," but also for "et alias"(!). The painted angels might, accordingly, be identified with the lat-

ily's residence (cf. Krautheimer, *Lorenzo Ghiberti*, 376f., docs. 81–86). The Via de' Cenni house was not, in any event, his workshop, which was opposite the Spedale di Santa Maria Nuova (cf. T. Krautheimer-Hess, "Ghibertiana," *AB*, XLVI, 1964, 307ff.). It should be noted, however, that in the *catasti* before 1442 (Krautheimer, *Lorenzo Ghiberti*, docs. 81–83) the Borgo Allegri house is described merely as "a uso di me e della mia famiglia," which would exempt its value from inclusion in his "sustanze." Some time before 1442 Ghiberti bought a "casetta allato" to his Borgo Allegri house from the widow of a deceased neighbor and then, the original house being too small, proceeded to combine the two into one larger building, a practice common in this period (cf. H. Saalman, "The Authorship of the Pazzi Palace," *AB*, XLVI, 1964, 390 n. 4). From 1442 on the Borgo Allegri house is described as "quali io habito," and in 1448 Ghiberti finally gave up the Via de' Cenni house. It would seem that between 1425 and 1442 Ghiberti lived in the rented place on Via de' Cenni, keeping the other house for family use (that is, not renting it out for income). After the enlargement in the 1440's, the Borgo Allegri house became a suitable full-time town house for a prosperous artist, and the practical Ghiberti must have decided that a rented house in the center of town was a needless expense.

50. See L. B. Alberti, *On Painting*, ed. J. R. Spencer, New Haven, 1956, 23f.

ter rather than with the *storie* with which they seem to be generically grouped in the 1446 payment.

The puzzling singular "istoriam"[51] of the March 4th document, when evidently there were at least two if not more *storie* involved, suggests a further possibility. It *could* be that the other two *storie* had been authorized during the period October, 1442–November, 1443, for which the record of deliberations is lost. Thus Ventura-Rossello *could* be responsible for the painting in the upper zone, finished as we have noted before March, 1445; Cellini's contribution would then be confined to the oratory bays as shown in Rustici B. The accounting with the two painters would have been deferred until after all the scenes were finished in 1446.

This last hypothesis has the advantage of clarifying the use of the term "istoria" and of putting the relatively smaller payment to Cellini into another light, but it also has some evident drawbacks. The "et alias" remains unaccounted for, and the 1446 payment, which covers "3 storie" only, leaves the angels—apparently painted by the same hands as the St. Peter Martyr scenes (in so far as can still be told from the almost wholly ruined paintings) and surely painted after March 18, 1445—out in the undocumented cold. As for the singular "istoriam," the volume of deliberations for the year November, 1445–October, 1446, is also missing, and the authorization for the second (and final!) *storia* could have been given in that period, which would accord with the chronology of the final accounting in August, 1446. This leaves only the not unlikely notary's slip in making three *storie* out of two figured scenes and the angels!

51. The word immediately preceding *istoriam* is illegible and might have modified it. The first letters appear to be "fi" (?) (cf. Doc. 14a).

4

The *Audienza Nova* and After

The rest of the Bigallo story is somewhat less problematic. In 1447 the traditional Misericordia function of caring for lost and orphaned children was reorganized and a *guardianus puerorum* put on the regular payroll.[52] Documents over the next forty years[53] make it clear that the *guardianus* lived in the residence with the orphans, possibly on the upper floor over the *udienza*. In 1448[54] the *capomaestro* was paid for installation of a wash basin and for "Achoncimj fecc nella abitazione della miserichordia dove abito il guardiano retiene e fanciullj."

On December 9, 1452 (Doc. 16a), the *capitani*, again in an expansive mood, decided to build a new *udienza* in the house they owned next door,[55] because the old meeting hall was "tam nimis parva et misera quod quando ipsi congregare volunt necesse est exire de ipsa . . . et se congregare in sala sup(er)ioris . . . ," the last, as we have observed, in evident reference to the hall over the

52. *Bigallo* 737, c. 137r; May 12, 1447. Earlier mention of the guardian in *Bigallo* v, 3, c. 15v (1436), c. 19v (1437) and c. 11v (1439). Cf. Doc. 9i.

53. For example, *Bigallo* x, 3, c. 10r, June 23, 1481: "aco(n)ciamentis . . . factis In domo misericordie ubi et in qua habitat

s(er) damianus sacrista et bartolomeus guidonis guardianus pueror(um) smarritor(um) . . ."

54. *Bigallo* 747, c. 144r, December 20, 1448.

55. Cf. note 39 above.

oratory. The climb up (see Chapter 6) was "valde incomoda" and whole situation brought "no(n) p(ar)va verecu(n)dia et minimus honor" to the society. One suspects that it was less the inadequate space of the old chamber than the desire for something modern that prompted this decision, because the new *udienza*, ready in July, 1453 (Docs. 16 b–g), and wholly preserved in the building adjoining the old residence (both now hidden behind the 1777 façade), has practically the same dimensions as the old (Text Figs. iii, vi). Its major architectural feature is a lunette vault on fairly good Michelozzesque console capitals, an asset the old unvaulted *udienza* lacked.

In 1488 the Misericordia brothers (among them, significantly, Lorenzo di Piero de' Medici) regained something of their former vigor and approved a new statute providing for resumption of burial of the dead.[56] In 1525 the two companies split again, the Misericordia eventually moving across the street where it remains to this day. The stairway around a little courtyard behind the house containing the new *udienza* and several rooms behind this courtyard (Text Fig. xi, D)—now the offices of the present-day Orfanotrofio del Bigallo—may be dated in the late sixteenth or early seventeenth century. A ceiling fresco in one of the rooms is in the style of Giovanni da San Giovanni. Various structures mentioned in the fifteenth and sixteenth century documents—for example, the "cucina" and the "scriptorium" and their superstructures, apparently located around the former courtyard in back of the old and new residences—have been swept away in the course of later changes and replaced by modern buildings (Docs. 17a–c).[57]

The Bigallo company was suppressed in 1776. The residence then underwent an external transformation in which the two houses disappeared behind a unified façade centered on the main portal (Fig. 1). The interior of the old residence and parts of the oratory were also subjected to extensive alterations, which will be discussed in the following chapters (cf. Docs. 23–26).

56. Morini, *Documenti*, 58ff., docs. 22–23.

57. Cf. also note 58 below.

<div style="text-align: right;">

5

The Residence Stairs

</div>

The question of access to the upper floor of the residence and to the *sala magna* over the oratory remains problematical. Richa, our main source before 1777 (Doc. 21),[58] begins his descriptive

58. *Bigallo* 1668 contains periodic inventories of the Bigallo-Misericordia complex beginning in 1436 and running to 1584. They are of interest to our discussion because the various items are listed under the place where they were preserved. Thus the 1436 inventory mentions the following: "Chiesa; sagrestia; Camera di prete; palco sopra la cucina." 1441: "Oratorio-Sagrestia; Nella Cella (?); Abitazione del prete; Camera del prete. 1446: Nella Volta [cellar?]; Sagristia, In Casa." 1453: "Chiesa; Sagrestia; Nel entrata della misericordia; In sala; in chasa nella abitazione del prete"; etc. The most interesting inventory is that of 1576, which has the following locations:
"Chiesa; Al entrare di Chiesa in Sagrestia un uscio; Al uscire di Sagrestia un usciolo o paravento [confirmation of Landini's observation that the sacristy originally opened into the *cortile*, probably through the barrel-vaulted "niche" on the southern side; see Doc. 22] Stanza dove si fermano le donne quando vengano a battezzare [apparently the old *udienza* where the *Libro Magno* for birth records was kept; cf. *Bigallo* II (1407), c. 149]; Nella audienza [i.e., the new post-1452 *udienza*]; Androne che va nella Corticina [central corridor?]; Alla prima Volta [?]; Alla seconda volta [perhaps both of these *volte* are in the cellar]; Un uscio . . . al principio della scala che va in casa il Sagrestano [stairs at rear of old *udienza*? cf. chaps. 5 and 6]; Un uscio a mezza scala; In sala del Sagrestano; In Camera in su la Sala [hence superstructures as early as the 16th century?]; In Camera su la Cucina; Cucina; Sopra il Salottino; sul terrazzo;" etc.
These last locations were either in a no longer existing adjunct behind the old residence, or in the upper parts of the new residence.

"tour" of the residence with the Gerini fresco on the façade, then gives a quick glance at some "Pitture vetuste" in the "andito dell' Udienza"[59] (Fig. 14), which he compares (apparently having entered the old *udienza*) with "quelle che occupano tutta la parete addirimpetto alla Porta del Magistrato," evidently the Tobias cycle on the east wall opposite the door (Fig. 12). Over this door ("a manritta di questa porta"; Fig. 11) he subsequently reports the presence of the *Misericordia* fresco (Fig. 13). Immediately after the account of the Tobias cycle ("cosi annerite, e guaste, che non è sperabile l'arrivare ad intenderle"), he refers to a painting of a "Cristo ritto nel Sepolcro . . . sul piano della scala, che con due braccia conduce al piano superiore." This would seem to be the open stairs against the rear wall of the *udienza* which appear in Rustici A (Fig. 7). Richa then leaves "questa loggetta," apparently through its open front.

Landini, writing in 1779, saw the complex both before and after the 1777 alterations. His description, copied almost word for word out of Richa, reflects an attempt to bring his source up to date by accounting, albeit clumsily and in scattered passages, for the changes wrought in the 1777 transformation (Doc. 22). Thus we learn that the sacristy flanking the third (western) bay of the oratory on its southern side (Text Fig. iii), not mentioned by Richa, originally opened onto the courtyard behind the old *udienza*. This was the state of things before the complex was "nell' anno 1777 a nuova forma ridotto."[60] In another passage Landini informs us that the fragments of the "pitture dipinte a fresco" (note the plural!), formerly "sopra il portone al di fuori," removed by a certain "maestro Teobaldo Bercilli" in 1777 and "fatte segare in due pezzi . . . hanno poi servito per chiudere l'atrio, e farvi una nuova stanza, che [apparently the "atrio" or courtyard behind the house] prima metteva nell'uffizio de' predetti sigg. capitani."[61] In this "stanza" were also other paintings "esprimenti molte opere del glorioso S. Pier Martire" (actually the Tobias cycle[62]). This cycle consisted of "diciotto quadri . . . dodici

59. The "Androne che va nella Corticina" of the 1576 inventory? See note 58 above.

60. P. Landini, *Istoria dell'Oratorio e della Venerabile Arciconfraternita di Santa Maria della Misericordia della città di Firenze* (1779), ed. P. Pillori, Florence, 1845, 16–17.

61. *Ibid.*, 21–22.

62. Poggi, "Bigallo," 206.

de' quali restano dentro la sopradetta stanza, e sei in altro luogo interno." After 1777 access to the sacristy from the residence "si vede essere rimasta in un piccolo andito, vicino ad un principio di scala di sette scalini che introduce a due scale, con branche di ferro, e davanti alla medesima . . . in una pittura sul legno un Cristo ritto nel sepolcro,"[63] apparently the same painting seen by Richa.

An examination of the present state of the complex (Figs. 10–12, 14–16; Text Figs. iii–v) allows us to clarify what Richa and Landini described. It appears, first of all, that the present rear wall of the old *udienza* (now the Sala del Consiglio) is a later insertion, comprising one of the "pezzi" (the Gerini fresco fragment) removed from the façade in 1777. The room, thus reduced in depth and with its formerly open front closed by the new (i.e., the present) façade, is Landini's "nuova stanza." Its prior condition can be reconstructed from Richa's description. Richa reported a "scala che con due braccia conduce al piano superiore." Since the Rustici miniature shows only one flight, rising from right to left, it may be proposed that the interior flight rose to a landing in the southeastern corner of the *udienza* (not shown in Rustici A). The landing led through an opening in the rear wall to an outer landing from which the second of the "due braccia" led up to the "piano superiore" as an open exterior flight (Text Figs. vi, viii).

None of our sources before or after 1777 describes the upper floor. This floor is divided into a room over the *udienza* and a corridor similar to that on the ground floor (Text Fig. iv). The room is at the 5.25m level (9 braccia) over the still existing original ceiling of the *udienza*, but the corridor is .76m lower at 4.49m, apparently as a result of changes made in 1777.[64] Four 19cm-high steps connect the room and the corridor.

After the *udienza* was reduced to its present extent in 1777, the old flight of steps remained in the new stairhall behind the inserted wall, to be reutilized as Landini's "principio di scala di sette scalini." Since the old flight ran against the former rear wall of the *udienza*, a reconstruction of both the pre- and post-1777

63. Landini, *Istoria . . . della Misericordia*, 17.

64. The ground floor corridor (Fig. 14) is covered with a flat, probably lightweight, vault. Cf. also Doc. 24.

states requires a determination of the exact location and character of that wall.

An approach to this problem must begin with an examination of the present stairhall (Figs. 14–16; Text Figs. iii, iv). Its plan, an irregular trapezoid, is due to the fact that the new rear wall of the *udienza* runs at a right angle to the western *udienza* wall, while the residence plan as a whole is decidedly trapezoidal with respect to the nearly due north-south and east-west axes of the Duomo and Baptistery, which give the major lines to the piazza in front of the Bigallo complex. The line of the 1777 wall was apparently determined by the desire to have the widest possible stairhall while preserving as much of the old *udienza* as possible, including at least twelve of the Tobias scenes on the eastern *udienza* wall. As it is, the new wall cuts 5cm into the southernmost of the four columns of fresco scenes remaining (Fig. 10).

In the present arrangement the first flight of steps, 1.13m wide and rising to a first landing at 2.31m on a thin supporting wall 15cm thick, lies immediately behind the 1777 rear wall. Next to it is an open stairwell, 1.23m wide at the corridor end, 1.10m at the end under the short north-south flight which leads to a second landing at 3.11m. The sacristy may now be entered by an arched door under the north-south flight (Fig. 16). The filleted profile of the *pietra serena* door frame suggests the fifteenth century, but the machine workmanship (fine stippling instead of the irregular chisel strokes typical for the Quattrocento) testifies to a more recent, nineteenth century origin. This, as we shall see, was not the post-1777 door to the sacristy seen by Landini "vicino ad un principio di scala di sette scalini."

The present stairwell is flanked on its southern side by a second 15cm-thick wall supporting the third flight of steps leading from the 3.11m landing to the first floor landing at 4.34m. This supporting wall is pierced at each end by doors with stone frames topped by voluted lintels (Fig. 15). The frames are of pre-nineteenth century origin and are reused here, since, as we shall see, the wall is surely of a later date. The door next to the corridor leads to an interior landing, 22cm below the ±0.00m ground floor level of the corridor and *udienza*. From the landing a flight of eleven steps leads down to the cellar (Text Fig. v), 2.31m below the main floor. This stairway is flanked by another wall, 1.05m to the south, whose thickness of .584m (exactly 1 braccia) can be

measured through a window between the present first- and second-floor landings (ca. 6m over the ground level.. An 80cm-square dumbwaiter shaft impinges on this wall in the corner between the stairhall and the southward extension (post-fifteenth century?) [65] of the corridor. Behind this wall lies what remains of the former courtyard of the residence, now crowded in by the surrounding buildings. The slight widening of the southern flights from east to west is due to the fact that the 15cm supporting wall runs nearly parallel to the 1777 *udienza* wall, while the .584m wall follows the decidedly south-southwest axis of the façade line.

A first question to be asked is: could the rear wall have been north of the stairwell; that is, was the old flight inside that wall in the place of the present first flight of steps? This question is resolved by a reconstruction of the Tobias scenes on the east wall of the *udienza* (Fig. 12; Text Figs. vi, vii, ix). The scenes, whose lower limit lies at 2.04m over the *udienza* floor level (±0.00m), are 82cm wide and 77cm high and are enclosed in 7cm-wide painted frames. The three scenes in the southernmost of the four remaining sections, partially overlapped by the 1777 south wall of the *udienza,* are only 77cm wide. Since Landini reported eighteen scenes in the original arrangement (and assuming that the lost scenes had the same dimension as the surviving scenes), 1.89m of the horizontal dimension of the fresco is now missing. The inserted wall is about one-half braccia (.295m) wide. Thus 1.60m of the fresco originally intruded into the space of the present stairhall. This brings us to within 63cm of the 15cm wall south of the stairwell and puts the location of the former rear wall beyond doubt south of the stairwell. It also eliminates the axis of the 15cm wall south of the stairwell as a possible location for the rear wall since the old stairs formerly in front of that wall were surely wider than 63cm. Since, in any event, the surviving peripheral walls of the residence—measurable at various points in the cellar and on the ground and upper floors—run from a minimum of 48cm thick (at the door to the *udienza*) to a maximum of 86cm (in the cellar), averaging around 58cm or 1 braccia (at the door to the sacristy), it may be asserted with some assurance that neither of the 15cm walls could be the wall in question.

This leaves only the southernmost wall which, in fact, meets

65. Cf. note 58 above.

all specifications: 1) its breadth of .584m corresponds to the average dimension of the other peripheral walls; 2) it runs parallel to the façade; 3) it continues the line of the rear wall of the adjacent building containing the new *udienza,* indicating that the two buildings originally shared the *cortile* in back;[66] 4) there is 1.76m between it and the Tobias fresco, more than enough for the interior stairs, estimated at approximately 2 braccia (1.16m) for the width of the stairs and one-quarter braccia (.1459m) for the bearing wall and balustrade.

With the former rear wall specified, the other pieces of the puzzle fall into place. The original interior dimensions of the old *udienza* were roughly 9.60 x 4.30m (16.5 x 7.5 braccia). The corridor measured 9.60 x 2.04m (16.5 x 3.5 braccia) with an average wall thickness of .58m (1 braccia), giving overall exterior dimensions of 10.20 x 7.77m (17.5 x 12.5 braccia), the party wall between the two adjacent buildings being counted at one-half braccia.

The information for a reconstruction of the old interior-exterior stairway leading to the upper residence floor is sparse but sufficient. That there *were* interior stairs leading part of the way up to the upper level (5.25m), and consequently exterior stairs behind the rear wall, is demonstrated by the Rustici miniature. Landini's "principio di scala" can hardly be other than the old stairs, still in place after the 1777 conversion, and Landini gives us the decisive information that there were seven steps. If we assume that these steps had the *maximum* height practicable, with risers of one-half braccia (.292m) and an equal depth, we would arrive at a landing at 2.04m (3.5 braccia), exactly in line with the bottom of the Tobias fresco. The inside flight would then have extended some 5 braccia (2.92m) across the back of the *udienza* with the three bottom steps curving around to the north (Text Figs. ii, vi, viii), as was suggested by Rustici A (Fig. 7).

That the landing was, in fact, at the 2.04m level is confirmed by some further observations. We have already referred to the fact that the present door opening between the stairwell and the sacristy was not the original means of communication between the sacristy and the *udienza.* An inspection of the below-stairs under the southern arm of the present stairway (Text Fig. iii) reveals that

66. See below, Docs. 17a–c.

the piece of the eastern residence wall facing on the below-stairs is pierced by a doorway. This doorway is now closed up by a 16cm-thick wall, leaving a 43cm-deep niche facing the below-stairs, but the old door hinges remain. The former door opening is topped by a flat arch with its apex at 1.92m. If, as might be expected, the landing of the old stairs lay immediately over this doorway, a floor thickness of 12cm (a little under the quarter braccia standard) would give a landing level of 2.04m.

From an exterior landing at 2.04m eleven additional half-braccia risers (.292m) would have brought the stairs to a landing at 5.25m in front of the upper corridor (Text Figs. ii, viii).

The major alterations effected in 1777 (cf. Docs. 23–26) were the following: The existing three-story façade was erected in front of the formerly separate buildings and was centered on the doorway in front of the old residence *andito*. The upper corridor level was lowered from 5.25m to 4.49m over a flat vault (Fig. 14). As we have already noted, the old *udienza* was reduced to an irregular trapezoid measuring 6.00 x 4.31 x 5.65 x 4.35m by the inserted wall running on an approximately east-southeast to west-northwest axis. The fragment of the original *udienza* ceiling remaining over the truncated room at 4.96m (8.5 braccia) was left in place, apparently in order to preserve the famous *Misericordia* fresco, which extends from the top of the door in the western *udienza* wall up to the ceiling (Fig. 11), as well as the Tobias fresco on the eastern wall which rises to 4.36m. The existing parquet floor (Fig. 10), tailored to the reduced *udienza* dimensions, must also date from the 1777 reconstruction.

Since, according to Landini, the old "scala di sette scalini" remained in its place, the "due scale con branche di ferro" which were its continuation to the upper floor must be reconstructed as two arms of a well stairway running counter-clockwise, with the upper of the two new arms running against the new 1777 rear wall of the reduced *udienza* (Text Figs. vii, ix). The ascent from the old landing at 2.04m to the new landing at 4.34m, running in front of and one step (15cm) below the new corridor level of 4.49m (equivalent to the present upper landing), could have been effected by five risers each 19cm high, 29cm deep, to an intermediate landing at 2.99m and by seven additional 19cm risers to the upper landing. While the semi-destruction of the historic old *udienza* is regrettable, it may be said that the postulated post-

1777 stairway, with its lower risers and intermediate landing, represents a step in the direction of eighteenth century elegance and comfort. It is evident, however, that this arrangement overlapped the area of the six Tobias scenes left outside the bounds of the reduced old *udienza*. The fresco fragment was apparently removed and preserved "in altro luogo interno," as Landini put it. When Pillori brought out his new edition of Landini's book in 1845, the fragment had apparently been lost, since he passed over Landini's reference to the missing scenes without a word of comment.

It should be noted that Landini's remarks on the entrance to the sacristy "rimasta in un piccolo andito, vicino ad un principio di scala di sette scalini," evidently refers to the former doorway under the landing of the old stairs in the southeast corner of the post-1777 stairhall. A rectangular niche, 40cm high. 70cm wide, 30cm deep, 85cm over the ground, cut into the former rear wall just in front of the door, probably for a holy water font, testifies to the former purpose of this door.

In his introduction to his new edition of Landini in 1845, Pillori refers to the "cambiamenti avvenuti dai tempi del Landini ai nostri," [67] but the replacement of the post-1777 arrangement by the present stairs (Text Figs. iii, x) must probably be dated after Pillori's time, since he lets Landini's report concerning the stairs stand unaltered. The character of the present stairs with their old-fashioned cast-iron balusters (Figs. 15, 16) does not help in deciding this point, since renovations and the addition of flights to three modern upper stories were effected in 1919. [68] While the two upper arms of the post-1777 stairway were, following Landini's report, supported on iron braces, the less graceful existing arrangement involved the insertion of the 15cm-thick bearing walls on each side of the stairwell. The two stone doorframes in the southern wall (Fig. 15), apparently of earlier vintage, must have been reused here. The need for the cellar stairway north of the southern wall, probably prompted by the installation of a now defunct coal furnace (serviced by the dumbwaiter north of the former

67. Pillori, in Landini, *Istoria . . . della Misericordia*, unnumbered page entitled "Avviso."

68. According to information supplied by the present custodian.

rear wall) some time in the latter half of the nineteenth century, apparently rang the final knell for the old "scala di sette scalini" and the post-1777 stairs. Three old steps, 80–93cm wide and roughly 20cm high (the top one at right angles to the lower two and partly buried under the western peripheral wall of the old *udienza*[69]), remain at a point directly under the landing at the top of the cellar stairs (Text Fig. v), the lowest, probably *in situ* at level −2.09m, indicating the run of a former cellar stairway, perhaps leading down from the *cortile.*

69. This situation is probably due to a rearrangement of the cellar area related to the installation of the furnace and dumb-waiter.

6

The Oratory Stairs

There is a discrepancy between the outer and inner systems of the oratory. While the exterior bay flanking the residence measures 4.21m from pilaster to pilaster, the corresponding vaulted interior bay has east-west dimensions of only 3.37m. The 84cm remaining on the western side of the bay comprises a niche covered by a barrel vault.[70] The niche is closed on the west by a roughly 38cm-thick wall built against the eastern *udienza* wall running at a slight angle behind it (Text Fig. iii). The sacristy adjoining the western oratory bay is a small, irregularly trapezoidal room measuring 3.21 x 2.63 x 3.27 x 2.95m.[71] In its southwestern corner is a niche 1.115m deep and 1.66m wide, covered by a barrel vault with its apex at 2.67m over the ±0.00m level of the residence ground floor. From a line 10cm over the niche apex springs a rising barrel vault 1.36m wide, running upward along the western sacristy wall and up against the northern sacristy wall at a height of 4.13m. From this level—roughly equivalent to the springing

70. Considerable traces of fresco decoration (Nardo di Cione?) remain in and around this niche, behind the now freestanding altar of 1515 (cf. photos by Soprintendenza alle Gallerie Nos. 14325, 41924).

71. The dimensions reported by Landini, *Istoria . . . della Misericordia*, 16–17 (Doc. 22), are evidently not based on a measured survey.

point of the oratory vaults at 4.20m—rises a north-south barrel vault, with its apex at 5.11m, which covers the remaining space of the sacristy (Text Figs. iii, viii). The rising vault in the sacristy and the niche vault in the oratory that is its continuation serve as the underpinnings of a stairway giving access to the present 7.34m level over the oratory vaults. This stairway, 1.26m wide at the lower (south) end and narrowing to 1.06m at the top, because of the inclination of the residence wall flanking it on the west, is now entered from a landing at the 5.25m level of the present residence stairway (Text Fig. iv). From this level eleven steps with 19cm risers lead to the 7.34m level. Ten additional steps of this stairway, now hidden under the thin wooden landing at 5.25m, continue this stairway down to a 97cm-deep landing at 3.28m, directly over the sacristy niche. This lower landing is now accessible through a door in the eastern residence wall at the 3.11m landing of the present residence stairway. The space with the ten steps forms a kind of triangular closet.

Given this evidence, it is possible to propose a reconstruction of the original form of the oratory stairway. It may be suggested that at least two additional 19cm-high steps of the original stairway remain hidden under the composition floor of the 3.28m landing, turning south within the space of the 97cm landing to meet three half braccia (29.2cm) risers that came up through the breadth of the residence wall from the 2.04m landing of the former interior stairs of the *udienza* (Text Figs. vi, viii, xii).[72]

I would also propose that this arrangement dates back to the construction of the oratory in the 1350's, when it provided access to the *sala magna* over the oratory vaults.[73] Long, narrow, and without any intermediate landing, it ran as an exterior stairway for perhaps half its length before entering under the oratory roof. It is not surprising that the *capitani* of 1452 found this arrangement "valde incomoda" (Doc. 16a). Nonetheless, it survived after the 1442 remanagement of the upper hall, no other practical alternative being at hand, and remained, it would seem, until

72. See the discussion in ch. 5 above.

73. The repeated reference in 1359–60 to the "lavorio . . . delle volte e dell'altro lavorio che intorno accio bisogna di fare" (Docs. 4, 5) may be interpreted as a reference to the construction of both the *sala magna* and the stairway leading up to it. Cf. p. 10 above.

the present residence stairway was created (Text Fig. ix). After 1453, in any event, the *capitani* and *arroti* met in the new *udienza* on the ground floor next door (Doc. 16g).

After the post-1777 stairs disappeared sometime in the second half of the nineteenth century, the oratory stairway became progressively shorter. First, the postulated two lower steps disappeared under the composition pavement of the present landing at 3.28m, one step over the 3.11m landing of the existing residence stairway. In a second phase the present access and landing were created at the 5.25m level, leaving ten steps hidden away below (Text Fig. x). Finally at an undetermined date the oratory stairway was continued upward as a reverse flight to the superstructures (seventeenth-nineteenth centuries?) over the oratory.[74]

74. Cf. the inventory of 1576 (quoted above, note 58): "Camera in su la Sala." The date at which the *sala magna* level was raised from the presumed original 6.75m to 7.34m, involving corresponding alterations in the adjacent stairway, addition of three more steps, and a new landing, also remains uncertain. Cf. also note 42 above.

7
In Retrospect

The present Orfanotrofio del Bigallo, a modest, privately supported organization, eventually succeeded the great old company. The old facade of the residence with its Misericordia fresco disappeared, and all the surviving pictures, once symbols of the competing companies, suffered equal neglect in a new secular age. The progressive bastardization of the interior of the venerable residence in which Cosimo de' Medici once officiated is an index of the totally altered character of public administration and civic social services in the later eighteenth and the nineteenth centuries. What little remained of architectural elegance after the reforms of Grand Duke Pietro Leopoldo and the French administration at the turn of the nineteenth century vanished in the grubby steam-heated comfort of the Florentine late *Ottocento*.

Documents

Some of the Bigallo documents in the following digest have been previously published by G. Poggi ("La Compagnia del Bigallo," *Rivista d'Arte*, II, 1904), L. Passerini (*Storia dei stabilimenti di Beneficienza . . . della città di Firenze*, Florence, 1853), and U. Morini (*Documenti inediti . . .*, Florence, 1940), and are re-published here in order to complete the record. Those without bibliographical references following the archival references are published here for the first time. All of the documents are preserved in the Archivio di Stato, Florence, under the general heading *Bigallo* but it should be kept in mind that the books written before 1425 derive from two sources, the archives of the Misericordia and those of the Compagnia del Bigallo. In using the pre-1425 volumes, care must be taken in ascertaining the sources which are not always evident from the contents. This is best done by checking the opening dedication to the respective patron saints of the two companies.

The books fall into two major categories: minutes of the meetings of the company captains, including authorization of expenditures; and of account books, recording income from the company properties (real estate), and expenditures for the charitable functions and festivities of the companies, for salaries of company employees, and for the maintenance and elaboration of the company

buildings. In addition there is a volume of inventories taken between 1436 and 1589 of the properties in the Bigallo oratory and residence. The Catasto volumes cited in Document 19 are also in the Archivio di Stato, Florence.

The writer has examined all the books, from the earliest (1348) up to 1480, and selected later volumes. While the account books from 1400 to 1776, when the Bigallo Company was suppressed, form an almost unbroken series, the books of minutes are only intermittently preserved, leaving occasional lacunae in the record of matters pertaining to the building history. However, every year between 1348 and 1500 is covered by one or the other of these books, making the record essentially complete.

Documents not previously published are given in the present writer's transcription. Other documents are printed here as they have appeared in published form, their accuracy having been checked against the original books by the present writer. These older transcriptions generally follow the common Italian practice of resolving abbreviations, separating words, and adding modern punctuation without placing these changes in parentheses. All dates are given according to the common style (*stile comune*) with the year beginning January 1 (Circumcision). The Florentine year began on March 25 (Annunciation). Thus, for example, March 15, 1425, *stile fiorentino*, is March 15, 1426, *stile comune* (S.C.).

1. Senator Carlo Strozzi's transcript of a document concerning the acquisition of the old residence building opposite San Giovanni in 1321–22.

Florence, Archivio di Stato, *Carte Strozziane* (old classification), Magliabecchiana, cl. XXXVII, cod. 300, c. 132 (Poggi, "Bigallo," 194 n. 1)

> *1321. Libro della Compagnia della Misericordia dove sono notati tutti quelli che aiutorno comperare la casa dirimpetto alla porta del Battesimo di S. Giovanni, comperata da Baldinaccio Adimari, dove hoggi si ragunano i capitani della Misericordia. 1321 et 1322 si fece la detta compera.*

2. Giovanni di Albizo Pellegrini leaves his house at the corner of the Corso degli Adimari and Piazza San Giovanni to the Misericordia.

Bigallo II, 1, c. 26r; September 16, 1351 (Poggi, "Bigallo," 225)

1351, 16 Settembre. Item dicta die Iohannes Albizi Pelle-grini populi s. Cristofori obtulit se et domum suam positam super canto Cursus de Adimaribus societati nostrae et fuit factus familiaris perpetuus (cum certis pactis) cum salario 8 lib. fp. quolibet mense. . . .

3. Demarkation of the site at the corner of Corso degli Adimari and Piazza San Giovanni for the new oratory of the Misericordia Company.
Bigallo II, 1, c. 28r; January 28, 1352 (Poggi, "Bigallo," 226)

. . . Item die 28 Ianuari magister Iohannes ser Pieri, men-surator Communis, et magister Thomasus Iacobi Passerae, magister communis, dederunt, praesentibus domino Bartolo canonico maioris ecclesiae flor. et aliis presbiteris et pluribus vicinis, situm edificando oratorium super canto plateae s. Iohannis capiendo braccia 10 terreni vel circa, incipiendo ex latere viae de Adimaribus iuxta columpnam domus con-tiguae dicto hedificio et ita posse fieri declaraverunt et roga-verunt per me notarium infrascriptum.

4. Election of *operai* for building of the oratory.
Bigallo II, 2, c. 19r; December 20, 1359 (Poggi, "Bigallo," 227)

. . . Item elexoro e chiamarono, per loro e per la detta com-pagnia, operai governatori e fabricatori del laborio dell'ora-torio, con balia di potere allogare i lavorio che si dee fare delle volte e dell'altro lavorio che intorno accio bisogna di fare a quelle persone che alloro piacera e per quel tempo e termine e con quel salaro e mercede che alloro piacera, voglendo che il detto mandato duri finito l'ofitio de detti Amaretto e Francesco capitani insino che il detto lavorio sia finito e compiuto.

5. Oratory construction in 1360.
a. *Bigallo* II, 2, c. 27r; March 23, 1360 (Poggi, "Bigallo," 227–28)

. . . In prima avuto consideratione alla constructione dell'oratorio e che bisogna e aconciare luogho dove le figure di marmo di nostra Donna e degl'agnoli, le quali si fanno e lavorano, si ponghano, e altre chose bisognia intorno al detto oratorio fare, e voglendo intorno accio provedere, deliberarono e stantiarono che Mattheo Portinari, camarlingho della detta compagnia, dea e paghi a Leonardo Bartolini tavoliere e a compagni fior. 100 d'oro, i quali il detto Leonardo debbia ispendere nel lavorio del detto oratorio e per quello fare adornare e cresciere.

b. *Bigallo* II, 2, c. 29v; June 5, 1360

Item deliberarono estantiavarono che Leonardo bartolinj dea epaghi a francesco salvinj p(ro) p(ar)te di pagam(en)to delavorio che deono fare aloratorio f. xiiij doro fecero labolletta.

c. *Bigallo* II, 2, c. 31r; August 26, 1360

Item deliberarono che Leonardo bartolinj de som(m)a alluj depositata dea epaghj a mattheo portinarj Camarlingho della detta c(om)pagnia p(er) ispendere dare e paghare a maestrj i(n) pietre calcina erena f. LX doro e di cio fecero La boll(etta) i(n) due p(ar)tite.

6. Oratory roof painted in June 1361.
Bigallo II, 2, c. 37r; June 30, 1361 (Poggi, "Bigallo," 228)

. . . In prima statiarono che il camarlingho paghi a Bartolomeo dipintore 1. 62. s. 3. d. 6, i quali dee avere per dipintura del tetto de l'oratorio

7. Niccolo di Pietro Gerini and Ambrogio di Baldese are paid for façade painting.
 a. *Bigallo* II, 3, c. 27v; July 5, 1386 (Poggi, "Bigallo," 229)

A Nicholo di Piero e Ambruogio di Baldese dipintori a di 22 di Giugno per resto del lavorio della dipintura della faccia dinanzi della casa della Misericordia fior. 17 d'oro.

b. *Bigallo* II, 3, c. 90r; November 21, 1392

Ambroxio Baldesis pictori pro expensis pro reactando picturam domus misericordiae in qua congregantur capitanei tam pro expensis factis per eum quam pro suo labore in totum 1. 8, s. 6

8. Documents concerning the *sala magna* ("udienza di sopra").

a. *Bigallo* II, 2, c. 38v; August 31, 1361 (Morini, *Documenti*, 35, Doc. XII)

. . . cassone il quale suso nella sala . . .[75]

b. *Bigallo* V, c. 3v; December 19, 1425

First recorded meeting of Misericordia-Bigallo captains and *arroti . . . in sala magna dicte sotietatis.*

c. *Bigallo* V, c. 29v; January 30, 1427

Meeting *i(n) sala mag(n)a domus residentie dicte sotietatis.*

d. *Bigallo* V, c. 62r; January 21, 1428

Meeting *i(n) sala mag(n)a dom(i) mis(er)icordie.*

e. *Bigallo* 739 c. 160 sinistra; March 23, 1437

Spese extraordinari deono dare l. quatro stanziati . . . sono p(er) 2 finestre i(n) pan(n)ate p(er) ludienza di sopra e una nello scrittoio disotto...l. 4

f. *Bigallo* VI, 5, c. 3v; January 29, 1451

Capitani et Consuli et Arroti . . . in dom(um) Residentie d(i)c(t)or(um) Capitaneoru(m) et in sala sup(er)iorj magna dicti domus ubi p(er)factis et negocijs dicte societatis soliti su(n)t choadunatj.

g. *Bigallo* X, 2, c. 3r; November 26, 1479

Inventory notarized *in domo et audienzia sup(er)iorj domus di(ctorum) capitaneor(um).*

75. This document might, of course, refer equally well to the upper room over the *udienza*.

9. Documents concerning the *domus* or *habitatione* over the oratory.

a. *Bigallo* v, 1, c. 54v; October 15, 1427

P(re)fati cap(itani) Insimul ut sup(ra) s(er)vat(is) s(er)vand(is) . . . Item deliberaveru(n)t Q(uod) loco Bartolomej Romanj olim familiar(ius) dicte sotietat(is) eligat(ur) unus cappella(nus) qui co(n)tinua p(er)maneat i(n) di(ct)a sotietat(e) et celebret missam q(u)alib(et) mane i(n) oratori(o) cum salari(o) p(er) di(cto)s capitan(eis) deliberandum est.

b. *Bigallo* v, 1, cc. 56r–56v; October 31, 1427

Prefati Capitanj Insimul p(er) ip(s)or(um) offit(ium) exser(cen)do co(n)gregati . . . (ser)vatis (ser)vand(is) . . . p(ro)viderunt et deliberaveru(n)t Quod Cappellanj oratorij p(er) eos eligendus i(n)telligatur ha(b)ere et ha(b)eat p(ro) suo salar(i)o quo(d)lib(et) an(n)o floren(os) vigintj aureos sibi solve(n)du(m) demens(ibus) i(n) mensi(bus) et et(iam) ha(b)eat ha(b)ita(tionem) domum posit(um) su(per) d(ict)um oratoriu(m) et ubj d(omi)nj cap(itanj) residentia(m) faciu(n)t.

Captains elect Ser Michele di Andrea *Cappellanu(m) et sagrestan(um) d(i)c(t)j oratorij p(er) uno an(n)o.*

c. *Bigallo* v, 1, cc. 67v–68r; March 16, 1428

Nicho mactei legniaiuolo p(ro) plur(ibus) op(er)ib(us) p(er) eium dat(um) . . . et i(n) domo i(n) quo ha(bi)tat chappellanj oratorij..l. 11 s. 10.
Item stantiaverunt Laure(n)tio guidonis fornacar(ius) p(er) pl(enissi)me laborii chalcina et lateri(tio) ha(b)it(um) abeo p(ro) laborerio ha(b)itatio(n)is chappellanj oratorij misericordia et aliis locis i(n) totum.............................l. 25 s. 4.
Martino Joha(nn)is familiarj dicte sotietatis p(er) plurib(us) expen(sis) p(er) eum fact(um) in pane et vino dat(um) magi(st)ris et manovali(bus) qui laboraveru(n)t In domo habitation(i)s Chappellanj oratorij . . . (et alia)......................l. 12 s. 3 d. 2.
Andrea Nofrij Lastraiuolo pro lapidibus et finestris per eum dat(um) p(er) apoteca sotietatis i(n) qua ha(b)itat Joha(nn)is corbinellj et p(er) apoteca merciarij et p(ro) domo habitationis Chappelanj oratorij in totum ut in memoriale c. 4
l. 9 s. 19.

*Leonardo Johannis mag(ist)ro p(ro) pluribus o(per)is p(ro)
se et p(ro) eius manovalibus p(er) eum dat(um) i(n) pluri(bus)
locis et domibus dictae sotietatis ut in memoriale c. 5*
<div align="right">*l. xxxiij s. iij.*</div>

d. *Bigallo* v, 1, c. 73v; May 27, 1428

*Mariano Charettaio p(er) embricis p(er) eum tra(n)smissis
ad Janua(m) Crucis et p(er) disgombrando plateam s(anct)j
xr(ist)ofanj i(n) totum l. tres s. unum d. otto......l. 3 s. 1 d. 8.*

e. *Bigallo* v, 1, c. 91r; January 26, 1429

Ser Michael Andreii reelected chaplain with the specification
*Et habitare possit i(n) domo d(ict)j oratorij et residentie
dictor(um) cap(itaneorum).*

f. *Bigallo* v, 3, c. 13v; January 1437

*p(er) labitazione del n(ostr)o sagrestano chesta sop(ra) alora-
torio ./. Bartolomeo di matteo da xi ad xviij dottobre p(er)
achonciatura dellaquaio alato al pozo chesebbe aronpere
el muro fino i(n) terra adrietro vanela fossa e p(er)noj dati
alionardo di giovanni m(agistr)o e ridolfo suo compangno
che vimisono op(er)e x a s. xv aldj.........................l. 7 s. 10.*

g. *Bigallo* v, 3, c. 13v; January, 1437

*Domenicho di giovannj detto domenichono del di largha et
compangnj fornaciaj a san friano devono avere ... Alla
casa dove abita lsagristano nella mis(er)icordia p(er) lchamino
eaquaio di licienza di zanobj buriellj adj 7 di genn(a)io
1436 p(er) st(aia) 12 di chalcina l. 1 s. 15 p(er) matt(onj)
650 Matt(onj) e quadruccj l. 5 s. 17.*

h. *Bigallo* 741, c. 88v (89 *sinistra*); May 9, 1441

*Spese estraordinarie. E ad detto l. 6 p(er) loro a bartolomeo
(di matteo famiglio dicasa) detto p(er) piu spese fatta nella
casa della miserico(r)dia dove abita il sagrestano....*

i. *Bigallo* 747, c. 142₁; March, 1448

*Giuliano di Bernardo Nostro capomaestro deavere Insino
di marzo 1447 l. ventuna s. 7 p(iccoli) et p(er) noj avuto op-
(er)e q(u)ato(r)dicj In chasa il nostro guardiano della mise-*

ricordia auno aq(u)aio E unpalcho ealtre chose E inchasa il nostro sagrestano uno aq(u)aio eachonciare unaltro E iltetto della miserichordia . . . (et al.)......................l. 21 s. 7.

j. *Bigallo* x, 2 c. 3r; November 26, 1479

Inventory notarized *in domo et audienzia sup(er)iorj domus di(ctorum) capitaneor(um).*

10. *Scriptorium* ("scrittoio di sotto") built in 1429.
a. *Bigallo* v, 1, c. 96v; March 2, 1429

Item mo(do) et forma p(re)di(cti)s deliberaver(un)t Q(uod) Johan(n)is scholaj de spinis p(ro)visore dicte sotietatis fierj faciat unum scriptoriu(m) Justa audientia(m) d(ict)or(um) cap(itaneorum) i(n) quo existant om(n)es librj et scriptura d(i)c(t)e sotietatis.

b. *Bigallo* v, 1, c. 105v; June 15, 1429

Leonardo Johan(n)is mag(ist)ro p(er) plurib(us) op(er)ibus p(er) eo p(er) eium discipulo et manovalis p(er) eium dat(um) i(n) faciend(um) scriptor(ium) audientie et disgombrando chalcinarios et pilastrell(os) in totum l. undecim s. tres.
l. 11 s. 3.

c. *Bigallo* v, 1, c. 106r; June 15, 1429

Johan(n)is de spinis p(re)d(ictum) p(er) pano lino virido feltrello nostro et bullette p(ro) scriptor(i)o audientiae in totum l. tres s. quattuor d. otto......................l. 3. s. 4. d. 8.

d. Cf. Document 8e.

11. Work on the "Casa" in 1431.
Bigallo 737, c. 165v; April–May, 1431

Acconcime della casa e muriglia della compagnia . . . E de dare adj 8 daprile l. quattordicj s. 11 p(er) spese in acco(n)ciare guardarobe et aquari della casa propria della misericordia come apare partitame(n)te algiornale aa [or 00] c. 41 pago biagio guafranj posto debj avere in q(ue)sto ac 171. . . . E dj 30 di magio alore(n)zo di michele capomaestro p(er) parte di de(narj) deavere p(er) piu op(er)e messe nella chasa della co(m)pagnia......................l. x s.-

12. Fire and rebuilding in the oratory (and residence?), July–September, 1442

a. *Bigallo* VI, 1, c. 18r; July 24, 1442 (Poggi, "Bigallo," 241)

Praefati domini Capitanei deliberaverunt quod domus dictae societatis et eorum residentiae heri combusta reficiatur quam citius poterit per eorum capudmagistrum et alios magistros necessarios et utiles pro dicto hedifitio pont [prout?] videbitur Provisori, et quod lignamen et alia necessaria capiantur a debitoribus dictae societatis ad maiorem utilitatem dictae societatis.

b. *Bigallo* VI, 1, c. 18v; July 24, 1442

Bartolomeo matteij famulo p(er) pluri(bus) expe(n)sis factis p(er) eum p(er) extingue(n)do ignem domus miserico(r)diae v(idelicet) p(er) una media lagena vinj p(ro) dando sex manovali(bus) per pane e p(er) sedicim mezzinis p(er) extinguenda dic(t)um ingnem i(n) totum libras settem soldis sedicim denari otto...l. 7 s. 16 d. 8.

c. *Bigallo* VI, 1, c. 20r; August 8, 1442

Bartolomeo mattej famuli dicte societatis p(er) solve(n)do pluribus magistris manovalibus planellis calcina et lateribus et embricis et aliis reb(us) p(er) rettando domum et tettum dic(t)e societatis de p(ro)ximo co(m)bustam libras centum...fp. - l. 100-

d. *Bigallo* VI, 1, c. 21r; September 6, 1442

p(ro) Bartolomeo mattej famulo d(i)c(t)e societatis p(ro) residuo expensa(rum) facta(rum) i(n) reactando domu(m) d(i)c(t)e societatis co(m)bustam ultra lignamina rena co(n)cio et fer(r)ame(nt)is i(n) totum libras sexagi(n)ta qui(n)q(ue) sol(di) tres f(iorini) p(iccoli).................................l. 65 s. 3.

e. *Bigallo* 742 c. 100r; August 8–September 6, 1442

Bartolomeo di mateo famiglio deavere p(er) queste chose p(er) luj pagatte p(er) Rifare lachasa dela mis(er)icho(r)dia p(er) mogia tue dj channe ep(er) 1900 pinele e p(er) 540 tra quadruccj e matonj e p(er) 450 e(m)bricj e p(er) cie(n)tto ci(n)qua(n)ta tegolj e per opere vejsej e mezzo dj maestero di chazuola e p(er) opere 18 dj maestero dj legname e p(er)

opere 45+ dj manovale e p(er) 32 pezzj dase dabetto e p(er) dare acharettaio Recho trave e portto charette sette dj chonncj e mo(n)tta ttuto la detta spesa cioe nele dette chase l(ire) cie(n)tto sessa(n)tta ci(n)que s(oldi) tue fu vedutta p(er) lionardo di benedetto di chomo i(n)sununa i(n)scritta che nela filzza di mano dj detto barttolomeo so(s)critta p(er) detto lionardo di benedetto di chomo p(er)o e chapittanj feciono eglj laves(s)e avedere e dela detta ispesa ne fare notta ala Rico(r)da(n)zze ac 9 per tutta nette posto ispese debino dare i(n) q(uesto) c. 130......................f. - l. 165 s. 3- echomincio la detta ispesa adj 8 daghosto 1442 efinj adj 6 disete(m)bre 1442

f. *Bigallo* 742, c. 129v; August, 1442

Spese estraordinarie . . . debono dare p(er) legniame auto dadomenicho legniaiuolo p(er) rifare la chasa dela mi(ser)ichordia cioe quela de ₚ(re)tte qu(an)do a(r)se posto domenicho debie auere i(n) q(uest)o c. 39 i(n)soma dj l(ire) setattuna s(oldi) sette d(enari) sei...........................l. 71. 7. 6.

g. *Bigallo* 742, c. 39r; August 8–15, 1442

Domenicho da luca legniaiuolo 5 travi dabete; 22 piani dabete; 22 pezzi pell [?] dapiettrato; . . . per tetto . . . 5 charettj di castagnio da pianelone di luca, 1 segiola; ogni cosa p(er) tetto . . . 13 piane dabete p(er) palcho . . . 2 piane perla tramezzo e per necessario . . . e le sop(ra)dette chose dette p(er) rachonciare la misericho(r)dia cioe la chasa de p(re)tte p(er)che arse....................................l. 71 s. 7 d. 6.

13. Façade painting by Piero Cellini and assistants, 1443–1444

a. *Bigallo* VI, 2, c. 10v; March 10, 1444 (Poggi, "Bigallo," 241)

Item Piero Cellini et sotiis pictoribus quamcumque quantitatem pecuniae quam ipsi et quilibet ipsorum recipere et habere deberent . . . pro occasione certarum picturarum factarum item et pro calce et pontibus l. 20 Item deliberaverunt quod eligantur magistri prout dictis Capitaneis videbitur pro extimando omne et totum et quidquid supradicti Pierus et socii fecerunt.

b. *Bigallo* VI, 2, c. 12v; May 5, 1444

. . . Item deliberaveru(n)t q(uod) provisor dictj societ(atis) teneatur et debeat eliger(e) duos pictorj magistros q(ui) habea(n)t extimere laboreriu(m) fact(um) p(er) pierus cellinj etc.

c. *Bigallo* 743, c. 76v; March, 1444(?)

Piero Cellini debited for payment of l. 20 as per the provision of March 10, 1444 (see Doc. 13a).

d. *Bigallo* 744, c. 96r; July 1, 1444 (Passerini, *Storia dei stabilimenti*, 799)

Piero Chellini dipintore deavere l(ire) trentotto iqualj sono p(er) dipinture afatto nella facciata dinanzj della chasa nostra quando arse nellan(n)o 1443 dachordo cholluj questo dj p(r)imo diluglio 1444 a spese i(n) q(uest)o c. 192l. 38

e. *Bigallo* 744, c. 95v; July 1, 1444

Cellini debited additional l. 18, making l. 38 together with balance of l. 20 paid previously (see Doc. 13C).

14. Authorization to paint scene(s?) of St. Peter Martyr
a. *Bigallo* VI, 3, c. 7r; March 4, 1445 (Poggi, "Bigallo," 241; transcription by Saalman)

. . . Item similj mo(do) et form(a) et s(er)vatis ut supra [capitani] deliberaveru(n)t et deliberando dederu(n)t et (con)cesseru(n)t lice(n)tiam plenissimam Gieronimo provisorj p(re)d(ict)o q(uod) possit facere pingi fi . . . [last letters of word illegible] Jstoria(m) s(an)c(t)j petrj martiris (et) al(ias) i(n) muro ubj coaduna(n)t capitanj existente super platea s(an)c(t)j Joh(a)nis et eo mo(do) et for(ma) eidem videb(itu)r co(n)venire etc.

b. *Bigallo* 746 (1446–47), cc. 7r, 10r; August 23, 1446 (Poggi, "Bigallo," 241)

Payments to Ventura di Moro, Rossello di Jacopo & Co. for façade painting.

Rossello e Giunta d'Iacopo dipintori dono avere a di 23 d'Aghosto fior. 15 sono per la meta di 3 storie dipintoci in

conpangnia di Ventura di Moro, dipintore, di Santo Piero martire ne la faccia dinanzi della nostra compagnia come sind(icho) d'accordo Lorenzo di Bartoluccio orafo [a tenant of the company; see Doc. 20] *e Bonaiuto dipintore, posto in questo c. 193 spese di conpangnia .'. . fior 15 (la schritta di mano del sindicho ne la filza)* . . .

. . . Ventura di Moro . . . di 23 d'aghosto fior. 15 sono per la ½ dipintura fattaci in chompagnia di Rossello dipintore de la storia di San Piero martire in la faccia dinanzi di nostra conpangnia chome sindicho Lorenzo di Bartoluccio dipintore e Bonaiuto di Giovanni dipintore, e la schritta di loro mano ne la filza. Posto in questo 193 f. 15.

15. Statues from former Bigallo residence affixed on Misericordia.
Bigallo vi, 3, c. 16v; March 18, 1445

Prefati d(omi)nj capitanej . . . stantiaverunt et deliberaverunt q(uod) Johan(ni)s cam(erarius) p(re)di(ctu)s detur et solvat ut supra Inf(ra)s(cripti) v(idelicet) Barthol(omeij) famulo offitij pro expensis factis i(n) eundo i(n) piano mugnonis et ad hospitale burghj de mo(n)teriggi Ac et(iam) ad hospitale s(an)c(t)j Andree in po(n)tas sieva Ac etiam pro expensis . . . [word illegible] *Inhodierna(m) diem factis Inponendo figuras scholpitas i(n) muro dicte sotietatis, cum operis datis In murame(n)to / Et faciendo pontem p(ro) p(re)dictis exeque(n)dis i(n) totum l(ire) trigi(n)ta q(ua)tro s(oldi) xj d(enari) duos f(iorini) p(iccoli)..........l. 34 s. 11 d. 2*

16. Documents concerning the *audientia nova*.
a. *Bigallo* vi, 7, c. 12r; December 9, 1452 (Poggi, "Bigallo," 242)

Memorati capitanei . . . advertentes qualiter eorum audientia est tam nimis parva et misera quod quando ipsi congregare volunt necesse est exire de ipsa et ire et se congregare In sala sup(er)ioris u(b)i congregant(ur) et dicti capitani et alij Arroti p(er) necessitatibus dictorum societatum faciendum et considerantes dictes capitanes [sic] *et aliis arrotis valde incomoda esse de dicta eorum parva audientia exire et alibi ire et q(uod) no(n) p(ar)va verecu(n)dia et minimus honor consequat(ur) dic(t)e loco exire p(er) negotiis dictorum so-*

tietatum facere et anco p(er) honore mangni societatis et non parvo beneficio consequendo dictis societatibus omni modo quo potuera(n)t vigore eorum auctoritatis et balie delibera-verunt quod de domo quae est penes et contigua dictae audi-entiae et qua non est locata ut modo pensio exigatur et quae alias locata fuit cuidam scultori [Pagno di Lapo Por-tigiani da Fiesole; cf. *Bigallo* VI, 6, c. 10v; August 30, 1452; Poggi, "Bigallo," 242] *fiat nova audientia in qua capitanei p(otue)r(in)t in futuro c(on)gregarj. . . .*

b. *Bigallo* VI, 7, c 17r; January, 1453

Building contract for new audience hall specifies *m(a)teriale et si di legname cio e inarmare e armadure fare si della volta et si del riparo dello sporto.*

c. *Bigallo* VI, 7, c. 18v; January 11, 1453

. . . Item stantiaverunt capitanei q(uod) d(ominu)s ghalleottus (camerarius) det et solvat magistris et manovalibus q(ui) faciu(n)t et c(on)stru(erun)t et mura(n)t audientia(m) use(ue) et In q(uan)titatum floren(os) vigintj ult(ra) florenos quad-raginta p(er) ip(s)os capitan(eos) usq(ue) in die(m) nova(m) decenbris p(roximo) p(assato) 1452 stantiat(um).

d. *Bigallo* VI, 7, c. 19r; January 11, 1453

Giovanni di Alessio provides a guarantor and accepts contract.

e. *Bigallo* VI, 7, c. 38r; May 13, 1453

Capitanei . . . stantiaverunt . . . Bernardo (Valori) p(re)d(i)c-(t)o libras ducientos qui(n)quagi(n)ta p(er) m(agistr)is mano-vali(bus) fornacariis scarpellator(is) et aliis p(er) nova audi-entia quod fit...l. 250 s.-

f. *Bigallo* VI, 7, c. 43r; June 30, 1453

L. 153 s. 11 authorized *per muraglia nove auldie(n)tie.* L. 15 s. 14 authorized *pro parte facture nove finestre viritj nove auldientie.*

g. *Bigallo* VI, 7, c. 47; July 18, 1453

First meeting in the new hall. *P(re)dicti capit(ane)j i(n) loco Inferiorj et Insala i(n) ter(r)eno p(ro)pe eor(um) nove*

auldientie more solit(um) adunatj p(er) eor(um) offitio exerciendo . . .

h. *Bigallo* VI, 7, c. 66v; October 12, 1453

Giovanni Rossi Fornaciaio paid l. 250 for the balance of materials for new *udienza.*

i. *Bigallo* VI, 7, c. 67v; October 25, 1453

Giuliano di Onofrio Lastraiulo paid l. 146 for "conci" for the new *udienza.*

j. *Bigallo* 751 (1456–57), c. 95v

Summary of expenses for the new *udienza. 1456. Spese del muramento deludienza nuova c(on)ven(ien)te chominc(i)ato de dare f(iorini) sessanta l(ire) cinquecento trentanove s(oldi) dodicj denari dalib(ro) S(egnato) S, c. 104*
 f. 60 l. 539 s. 12 d.-

k. *Bigallo* IX, 2, c. 1v; November 2, 1471

Three doors *de novi hostia audientie dicto(rum) capitan(eorum) et sic fueru(n)t facta dicta hostia v(idelicet) tre unu(m) magnu(m) in p(ri)ncipio audientie alter(um) in fino alterum in loco notarij dicti offitii.*

17. Documents concerning the courtyard behind the two audience halls.

a. *Bigallo* VI, 7, c. 30r; March, 1453

Captains allow for a reduction in the tribute (candle wax on feast of St. Peter Martyr) to be paid by the tenants of a piece of land directly behind the old *udienza:*
cierta(m) ter(r)enum p(ro)pe domum suum et p(ro)pe audienti(am) veter(em) . . . p(er) actando di(i)c(tum) eor(um) offitiu(m) et nove eor(um) audientia aliqua(n)tulum accipe(re) p(er) itine(re) et gressu faciendo Ineundo Incuria q(uod) i(n)tendu(n)t In p(raese)ntiar(um) d(i)c(t)i capitanei facie retro d(i)c(t)a eo(rum) nova audientia . . . terreno (con)tiguo audie(n)tie veterj q(uod) est p(ro)pe puteum d(i)c(t)e domus mis(er)icordie . . .

b. *Bigallo* VI, 7, c. 39v; May 14, 1453

Church of S. Cristofano claims part of their land is being used *pro faciendo curia(m) retro nove audie(n)tie.* Ask Archbishop Antoninus to arbitrate and promise to be bound by his decision.

c. *Bigallo* VI, 8, cc. 13v–14r; October 6, 1453

Laudo of St. Antoninus. The saint decides that the land in question belongs to the church of San Cristofano. Bigallo must pay 14 florins for the terrain used in making the courtyard. Further, *et si p(er) honesta della chiesa et non nemo per la honesta della chasa v(os)tra se si puo fare senza uscio di drieto no(n) si faci(a).*

18. Oculus to be made in oratory in 1454.
Bigallo VI, 8, c. 32v; July 11, 1454 (Poggi, "Bigallo," 243)

Item deliberaverunt quod in oratorio sanctae Mariae et dictae domus Misericordiae fiat unum oculum de vetro pro demonstrando lumen et quod pro faciendo dictum oculum expendatur id pretium et quantitas fuerit expediens et quod Nicholaus de Biliottis camerarius sine aliquo suo preiudicio vel gravamine det et solvat omnen quantitatem pecuniae quae spenderetur in faciendo dictum oculum.

19. *Catasto* of 1429 of the Bigallo-Misericordia Company.
a. *Catasto* 291, c. 68

Sustanze de

La chompagnia del bighallo e della miserichordia dj firenze A tra possessionj mobili e(d) imobili e dj monte chome partitamente apare alli(bro) dellarchiveschovado dj firenze ac 665 e 687 ridottj inuna somma f(iorini) 15 751 s(oldi) 18 d(enari) 2 ad(enari) [sic]. E piu anno tutti gli spedali iqualj sono aloro ghoverno f(iorini) dumila treciento trentatre s(oldi) tredicij d(enari) quattro sono in tutto f(iorini) 18 085 s(oldi) 11 d(enari) 6

b. *Catasto* 293, cc. 34v–36v.

List of hospices dependent on Bigallo-Misericordia Company (number following name indicates number of beds as given in the *catasto*).

1. Spedale di Santa Maria alle Fonti (Bigallo)
2. Spedale di Monticielli

3. Spedale di Santa Maria a Monte Fichalli
4. Spedale di Santa Lucia de' Magnoli (21)
5. Spedale di Santa Maria dell'Umiltà in Borgo Ognissanti (18)
6. Spedale di San Lorenzo a San Pier Gattolino (12)
7. Spedale di Santa Maria in Pian di Mugnone
8. Spedale di Sant Andrea in Perchusina
9. Spedale di San Niccolo a San Felice in Piazza (7)
10. Spedale di San Jacopo a Sesto (16)

20. Bigallo documents concerning Lorenzo Ghiberti
a. *Bigallo* 735 (1424–27), c. 160v

Lorenzo di bartolo orafo de dare f(iorini) tredicj s(oldi) iiii d(enari) ii p(icco)lj posto abia dato lib(ro) biancho della mis(er)icordia segnato C ac 48 sono p(er) resto duna allogha-gione aluj fatta p(er) annj cinque cominciatj adj p(rim)o dinovembre 1425 e finiscano adj ultimo dottobre 1430 p(er) f(iorini) tre lano duno terzo duna casa posta nella via dj cinnj [or "cennj"; cf. Bigallo 738, c. 77v] lasciato alla mis(er)i-cordia per giuliano di lipo giulianj che laltro terzo lascio a fratj di s(an)c(t)a m(aria) novella laltro terzo alospedale di sanpagholo e tochava p(er) parte f(iorini) 3 lannof. xiij s. iiij d. ij.

b. *Bigallo* 747 (1448–49), c. 4v

Last rent payment by Lorenzo Ghiberti. House rented to new tenant as of November 1, 1448. Cf. *Bigallo* 747, c. 26v: "...casa...nella quale stava Lorenzo di Bartolo..."

c. *Bigallo* 741 (1441–42), c. 89v

Eadi 18 di luglio 1441 l(ire) sette s(oldi) 16 per loro a lorenzo di bartolo orafo posto deavere i(n) q(uest)o c. 3 sono p(er) piu spese fatte nella casa dove elista i(n) sino a q(uest)o di appare a Libro S ac. 5...l. 7 s. 16.

d. *Bigallo* 742 (1442–43), c. 3r

Lorenzo di barttolo orafo dirimpetto ... de avere i(n)sino 1436 p(er) piu lavorj p(er) luj fatti e detti cioe uno chalice e una patene eduno i(n)smltto [sic] chome appare ancho ac. 26 p(er) tutte ogette e la scritta nela filza datta

p(er) luj posta ispese [last two words crossed out] *l(ire) quin-*
dicj s(oldi) diecj sette posto Ispese debino dare i(n) q(uest)o
c. 131 ...l. 15 s. 17.

21. Giuseppe Richa's description of the Bigallo residence in
1758 (G. Richa, *Notizie istoriche delle chiese fiorentine*, VII,
Florence, 1758, 293–95).

E pero consideriamo una pittura grande sopra il Portone al
di fuori dipinta a fresco rappresentante in varie, e belle at-
titudini, dove molti Fanciulli smarriti, e dove delle Madri
chi afflitta per la perdita del figlio, e chi in aria allegra per
vederselo restituire da' Capitani del Bigallo, veggendosi in
tale dipintura molte Case, e Torri all'uso di que'tempi, cioe
del 1444 come travosi notato al lib. x pag. 8 nell'Archivio
del medesimo Bigallo, dove si legge anche il nome del Pittore
e dice, 1444. 1 Iunii Capitanei S. Marie Virginis, & Mise-
ricordie del Bigallo &c. ordinano pagarsi diversi obblighi
del loro Spedale &c. Item Piero Chellino Pictori pro resto
totius sue Picture facte in Domo habitationis Capitaneorum
in facie exteriori. Nell andito dell'Udienza sonovi alquante
Pitture vetuste, come quelle che occupano tutta la parete
addirimpetto alla Porta del Magistrato, ma cosi annerite,
e guaste, che non e sperabile l'arrivare ad intenderle: sul
piano della scala, che con due braccia conduce al piano supe-
riore, vedesi un Cristo ritto nel Sepolcro, colle braccia aperte,
tenente nel senno una moltitudine di gente per esprimere
la Misericordia, e sotto due Cartelli di caratteri gottici, che
dicono: O volgente XXI. E a manritta di questa porta
viene una parimente antichissima pittura a fresco, ed una
Figura gigantesca della Misericordia espressa in una Persona
ammantata di Piviale con Mitra tonda in capo, e Stolone
fino ai piedi, nella quale Stola veggonsi alcuni ovati, in cui
sono effigiate le Opere della Misericordia con lettere longo-
barde. Questa figura sta in aria in atto maestoso di padrona,
sopra a Firenze dipintale sotto con Popolo inginocchioni,
e chi bramasse sapere qual fosse il secondo Cerchio della
Citta, lo veda quivi delineato. Il Pittore di questa Tavola
spiego la sua idea con le seguenti lettere mezze gottiche, ma
rifiorite sull'antiche, e dichono: OMNIS MISERICORDIA
FACIET LOCVM VNICVIQVE SECVNDVM MERITVM

OPERVM SVORVM, ET SECVNDVM INTELLECTVM PE-REGRINATIONIS ILLIVS ANNO MCCCLII.

Uscendo da questra loggetta a man destra sono nel muro numero sei arpioni alti dal piano degli scalini due in tre braccia, de' quali s'ha certa tradizione, che servissero per attaccarvi la Cattedra, quando San Pier Martire predicava in sue questa Piazza; della qual cosa non avendo altra autenticazione, che il detto di qualche Persona antica, mi bastera di averlo qui accennato, lasciando a ciascuno giudicare come gli piace. E sulla Porta dell'Udienza, oltre l'arme de' Granduchi evvi un Cartello contenente a caratteri d'oro queste lettere; SERENISS. COSMO MAGNO D. HETRVRIAE / XII. VIRI CVM CERTIS PIETATIS MINISTERIIS / ET PVERIS DERELICTIS CVM ALIQVA ECCLESIAST. / DIGNI PERSONA COLLIGENDIS ET CVRANDIS PRAEFECTI.

22. P. Landini's description of the oratory and residence (first published 1779) with notes by P. Pillori (published 1845) (P. Landini, *Istoria dell'Oratorio . . . della Misericordia . . . con Note illustrata dall'Abate Pietro Pillori*, Florence, 1845).

Pp. 16–17: *Parimente in detto oratorio ad uso e comodo di sagrestia vi e annessa una stanza di lunghezza braccia otto, e di larghezza braccia sei, che aveva l'ingresso in un atrio ben grande dell ufizio, che teneva il magistrato de' sigg. capitani del Bigallo, prima che fosse quello nell'anno 1777 a nuova forma ridotto.*

Pillori, p. 17 no. 1: *I fratelli della compagnia della Misericordia acquistarono da Baldinaccio Adimari nel 1340 alcune case, e da queste, oltre la residenza pe' capitani, levarono una stanza per uso di sagrestia, che ora piu non esiste.*

P. 17: *Presentemente la comunicazione della sopradetta sagrestia, la quale fu comprata da Baldinaccio Adimari, si vede essere rimasta in un piccolo andito, vicino ad un principio di scala di sette scalini che introduce a due scale, con branche di ferro, e davanti alla medesima, ben conservato, si vede espresso in una pittura sul legno un Cristo ritto nel*

*sepolcro con le braccia apere che tiene nel seno una molti-
tudine di gente, per esprimere la Misericordia, e sotto due
cartelli di caratteri gotici, che dicono. . . .*

P. 21: *Si vedevano al pubblico esposte sopra il portone al
di fuori, che conduceva in detto luogo alcune pitture dipinte
a fresco l'anno 1444 rappresentanti in varie attitudini alcuni
fanciulli smarriti, e fra essi alcune madri afflitte per la perdita
dei loro figliuoli, ed altre in aria allegra per vederseli resti-
tuire dai capitani; e benchè consumate dal tempo vi si vedono
alcune case, e torri all'uso di quei tempi. Trovasi di tale
pittura descritto l'autore nell'archivio del commissariato
nel lib. X, alla pag. 8, ove si legge PRIMO IUNII PETRO
CHELLINIO PICTORI PRO RESTO TOTIUS PICTURAE
FACTA IN DOMO HABITATIONIS CAPITANORUM IN
FACIE EXTERIORI. Ma tutte queste pitture dal presente
commissario in occasione della nuova fabbrica, fatta per
miglior comodita de' poveri abbandonati con somma at-
tenzione e diligenza, e accio non si perdesse del tutto tal
memoria, nel mese di settembre dell'anno 1777 furono in
poco tempo, per mezzo di maestro Teobaldo Bercilli, fatte
segare in due pezzi, che trasportati hanno poi servito per
chiudere l'atrio, e farvi una nuova stanza, che prima metteva
nell'ufizio de' predetti sigg. capitani; nella quale sono state
unite altre pitture e memorie antiche esprimenti molte opere
del glorioso S. Pier Martire, ed una figura rappresentante la
Misericordia.*

*Nel mese di dicembre di detto anno, dopo che fu ultimata
la nuova fabbrica del prenominato sig. commissario fu or-
dinato che per mano di Santi Pacini fossero ripulite tutte;
come pure diciotto quadri di altezza, e larghezza di braccia
uno e un sesto, dodici de' quali restano dentro la sopradetta
stanza, e sei in altro luogo interno, degni di ogni bellezza,
per l'attenzione usata dal detto professore.*

Pillori, p. 22 n. 1, inscription under "Fanciulli Smarriti"
fragment: *FLORENTINI ORPHANOTROPHI MONV-
MENTVM / EXTERNAE AEDIS HVIVSCE PARIETI /
GRAPHICE A VETERIBVS CONSIGNATVM / HAC IN
NVPERRIMA EIVSMET RESTAVRATIONE / ARTE TRANS-
LATVM ANNO MDCCLXXVII / PETRO LEOPOLDO I*

ARCHID. AVST. / NEC NON MAG. ETR. DUC. / PIE CLE-
MENTER QVE FAVENTE [76]

Pillori, p. 22 n. 2: *Anche tutte queste pitture restano ora nella stanza del cassiere del Bigallo. Quelle esprimenti alcuni fatti della vita di S. Pier Martire sono molto annerite e guaste, e si scorgono nella parete dirimpetto alla porta, che introduceva un tempo alla residenza del magistrato, sulla quale tuttora si vedono le armi della Misericordia e del Bigallo in un solo scudo ridotte.*

Pp. 37–39: *. . . una pittura antica esprimente la Misericordia, la quale ora resta in una nuova stanza del commissariato del Bigallo. Questa stanza fu tutta dipinta nel mese di novembre dell'anno 1777 da Francesco Panaiotti, ed ora serve per uso del detto sig. commissario . . . La medesima pittura nel mese di dicembre dell'anno 1777 dopo la terminazione della nuova fabbrica, fatta per maggior comodita degli abbandonati, per ordine del sig. commissario fu fatta ripulire da Santi Pacini insieme con gli altri diciotto quadri esistenti in parte nella medesima stanza; di altezza braccia uno e un sesto, esprimenti le piu stupende azioni di S. Pier Martire . . .*

Pillori, p. 39 n. 1: *Tutte queste pitture molto ben conservate si vedono tuttora nella stanza del cassiere del Bigallo: le dodici esprimenti le azioni di S. Pier Martire sono un poco annerite e guaste. . . . Il Becchi nel suo illustratore Fiorentino a ragione si lamentò che alla parete ov'è la pittura esprimente la Misericordia si fosse in addietro fatto attaccare un casotto da impiegati che la danneggiava, e ne impediva la vista. Ma recentemente è stato staccato dal muro quel casotto, e sbassato.*

23. Bill for Architectural Services Rendered by Ing. Paolo Piccardi in the 1777 Rebuilding of the Residence. *Bigallo* 561, No. 281. November 15, 1777.

76. Pillori's transcription is slightly inaccurate. The correct transcription is given by Poggi, "Bigallo," 208.

Adi 15 Nov. 1777. Conto del Regio Ufizio di S. Ma. del Bigallo per vari Disegni della Fabbrica fatta sulla Piazza del Duomo per Uso degli Abbandonati. e per L'Assistenza fatta a detta Fabbrica dame Paolo Piccardi Perito Ingeg(nere).
Adi 12 Maggio 1777. Visitato la prima Volta i quartieri sopra al d(ett)o Ufizio per trovare il comodo per L'Abitazione de Fanciulli e Fanciulle Abbandonate e per i Ministri e Custodi del med(esimo) Ufizio. Dipoi fatto il disegno della facciata della d(ett)a Fabbrica come stava, avendo prese Le Misure di tutto e fatto detto disegno Acquarellato etc. fatto il nuovo disegno di come potevasi ridurre. Fatto il disegno della Porta principale in maggior proporzione e di una finestra per Piano e tutto disegnato nella Sua grandezza e fatto i Modini per gli Scarpellini e muratori con altri disegni del [sic] Camminate, Scalinate etc; che per tutti i Sud(ett)i lavori si pone in conto z. 40- Per l'assistenza prestata a d.a Fabbrica dal Suo principio alla fine che circa a Sei Mesi attuto Ottobre p(rossimo) p(assat)o statovi quasi di Continovi, che secondo il registro tenuto sono No. 160 Visite a z. 1½ L'una ammontano a z. 240. E per i Sudd. Disegni, Conti tarati etc. Si riportano

z. 40
240
―――
Somma in tuto z. 280
(approved) Marco Covoni Com(issar)io

The drawings mentioned here do not seem to have survived in the Bigallo archives; lack of time, however, did not allow an exhaustive search in all possible places.

24. Excerpts from the Accounts of Teobaldo Berzilli, Capo-Muratore in the Rebuilding of the Bigallo Residence, 1777. *Bigallo* 561, No. 288, beginning on May 17, 1777, running to October 18, 1777.
The accounts presented by Berzilli are kept in frustratingly generic terms. With some exceptions it is difficult to relate the accounts to specific parts of the present complex.

(May 17) *Disfatto un palco e rifatto piu basso ove sta il Pergolini* . . . (May 31) *messa su una scala* . . . (June 1)

fatto di nuovo la nicchia [?] . . . (June 14) *messa su una finestra nella Camera ove stanno le fanciulle* . . . (June 21) *finita* . . . *La Scala che conduce al terazzo* . . . (June 28) . . . *alzati piu sostamattoni* (i.e. brick walls) *nelle Camere del Signore Proposto, disfatti i mattoni e parte rifatti di nuovo, murati piu usci e intonacati; risteso un Rimpello, ov'era la Scala vecchia per metter Su la nuova, disfatti piu mattonati Sosta il Pergolini, rifatti piu Intonachi alla Scala, nuova* . . . (July 5) . . . *messa su una branca di Scala disfatte piu scale, messo un pezzo di Stoia auno Strombo della Scala* . . . (July 19) . . . *messa Su una branca di Scala . . . finito di mattonare il Dormentorio delle Fanciulle* . . . (July 26) . . . *cavate le finestre dell'ultimo piano alla facciata* . . . (August 2) . . . *ripieno un Strombo di una Scala . . . principiato a fare Le mostre alle finestre dell'Ultimo piano della facciata; fatti piu sterri in Cantina per ritrovare i fondamenti della Facciata* . . . (August 16) . . . *messa la montata per salire alla finestra nella Corte* (no trace of this now) . . . (August 23) . . . *disfatte piu mura vecchie . . . buttata giu una Volta, ove si va in Cantina e rifatta di nuovo . . . principiato a rompere Sosta Le finestre vecchie del 1mo piano per mettervi Le giunte* . . . (August 30) . . . *fatto un tramezzo di Sostamatto a terreno* (back wall of Sala dei Capitani?) . . . *finite piu finestre alla facciata, principiato a segare il Sostamattone ov'erano Le Pitture* . . . (September 7) *principiato a metter Su la Porta di Strada, fatta la Sua Tottura, puntellate piu mura per cavar Le pitture Segato il sostamattone . . . cavati i Sostamattoni ov'erano le Pitture fatti i Tirari dentro e fuori per murar Le al Suo posto* . . . (September 13) . . . *rifatta La Volta dentro alla Porta che serve il passare, finita di metter su la Porta . . . finito di mettere Le Pitture al Suo Posto* . . . (September 27) . . . *messa su La Scalinata della Porta . . . messa Su la Stoia sosta il ripiano della Scala* . . . (October 18) . . . *messi piu ferri alle Scale che servono per braccioli Somma L. 5091.17.*

25. Excerpts from Account of Giuseppe Chidini and Giovanni Spigagli Imbianchatori Compagni. *Bigallo* 561, No. 279. May 28, 1777.
These accounts involve painting of the various parts mentioned.

. . . la Stanza sopra in Volta con la Scaletta che si scende
(room over oratory since no other upper rooms are vaulted)
*. . . palchetti che sono nella Scalla dal Secondo Piano Sino
al Ricetto del tereno . . . Stipitti dj due Porte in detta Scalla
. . . Scalle dal Secondo Piano Sino al primo con le mura del
Anditto . . . machiatto di colore di marmo una porta in detta
Scala . . . Ricetto fori in Volta . . . due Porte in detto Ricetto
. . . il Palco del Ricetto a pie della Scalla . . . la Stanza del
Udienza in Volta nel Ufizio* (the audienza nova) *. . . Cortile
del Ufizio sino a tetto . . . tre facciatte della Corte . . . datto
di giesso alla gronda della facciata su la piazza . . . tinto
di colore di Calcina le Mura della Facciata e tinto in parte
della Facciatina a canto* (oratory?) *. . . mura delle Scalle
dal Secondo piano sino a Tereno . . . Stanza in Volta dove
Sta il Cassiere*

26. Excerpts from Account of Pasquale Petrai Legnaiuolo
Bigallo 562. No. 133. October 14, 1777.

*. . . per avere ressetto L'uscio dela Scala che si va in cantina
. . . per avere riguardato e Stuccato Tutto l'ornamento di
quadro della pietra a Capo di Scala e rimesso a Suo posto . . .
per avere Assetto Luscio a Capo di scala . . .*

The Bigallo After the Flood

On November 4, 1966, the Bigallo was caught in the vortex that swirled around Piazza San Giovanni. The water line reached about ten feet above ground level in the lower story. The sculptural decoration of the loggia was somewhat damaged by fast moving objects including logs, flotsam, and entire automobiles (Fig. 21). The fuel oil mixed with the water has left the entire marble surface covered with a black stain. Arnoldi's sculptural altar and the predella pieces by Ridolfo Ghirlandaio sustained water damage. Worst hit by the flood were the furnishings of the "Sala del Consiglio," the section of the old *Udienza* remaining after the re-management of 1777.

The state of the complex (February 1969) is as follows: The interior and exterior of the loggia and oratory have been restored and replastered under the direction of the Soprintendenza ai Monumenti and the Soprintendenza alle Gallerie with funds from German donors and the Italian government. The "Sala del Consiglio" is still under repair. The post-1777 parquet floor has been removed and may be destroyed. The fresco with the twelve surviving Tobias scenes has been detached from the wall and is under restoration. The water-color painting in its glassed frame showing the Gerini-Baldese fresco in its original state which formerly hung under the Tobias cycle has been temporarily stored in a vacant apartment on the third floor of the building. The Gerini-Baldese fragments are on the south wall awaiting

treatment. The *Misericordia* fresco is being restored *in situ*. The *audienza nova,* which contains a retail store, has been refurbished and does not seem to have sustained serious damage. The rest of the complex has received new plaster and paint and appears otherwise unharmed.

The Sopraintendente ai Monumenti, arch. Guido Morozzi, in a recent interview, stated that plans to restore the complex to its earlier state are under consideration. Since not a trace of the lost original materials (*scala vecchia,* etc.) survives, such an attempt would, in the view of the present writer, carry with it an overwhelming number of imponderables.

Illustrations

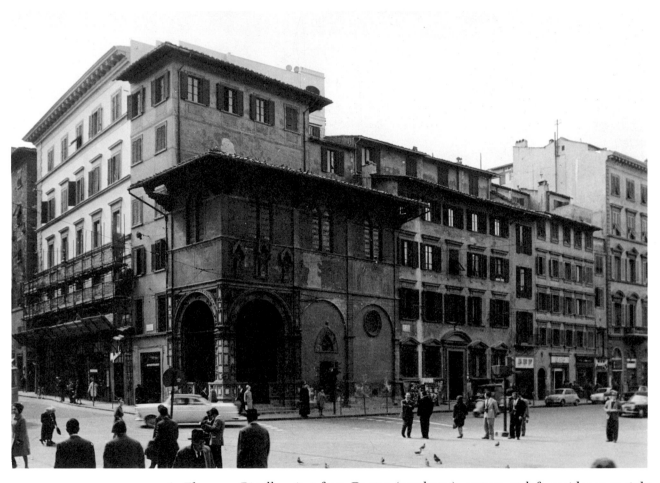

1. Florence, Bigallo, view from Duomo (northeast): oratory at left, residence at right

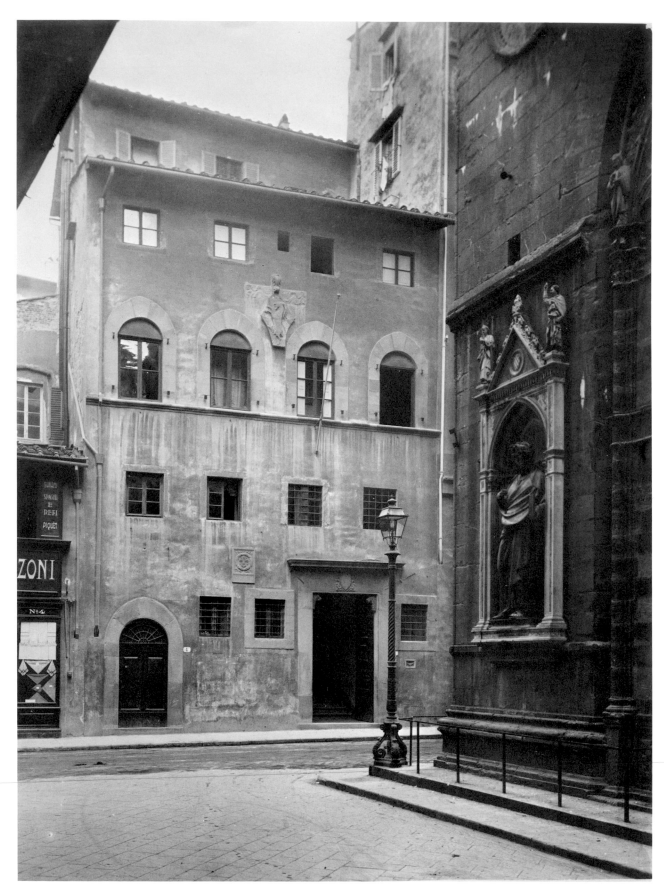

2. *Florence, Arte dei Beccai, Piazza Or San Michele, after 1429 (?)*

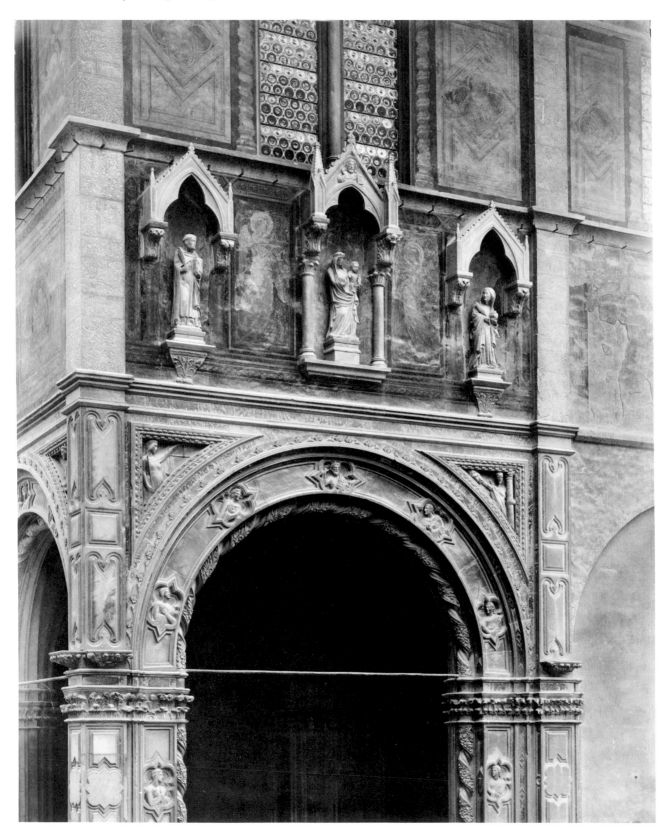

3. *Florence, Bigallo, oratory with statues of Virgin and Child, St. Peter Martyr, and St. Lucy, formerly on Bigallo residence in Corso de' Adimari*

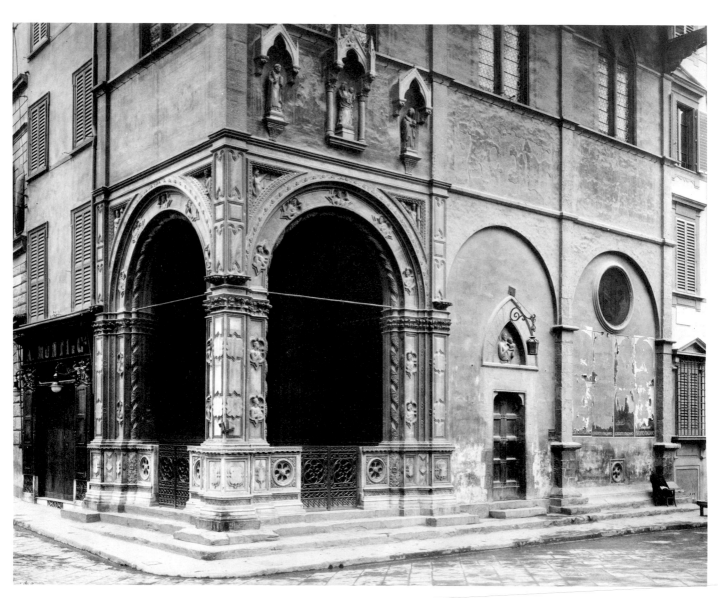

4. Florence, Bigallo, oratory

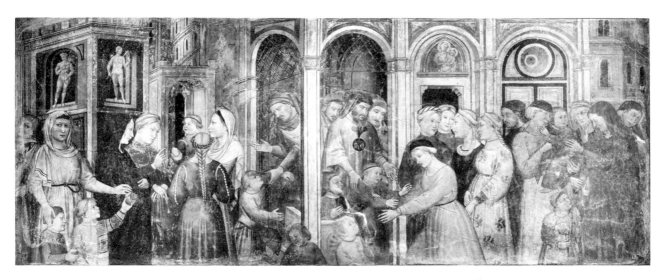

5. *Niccolo di Pietro Gerini and Ambrogio di Baldese*, Fanciulli smaritti, *fresco, 1386. Florence, Bigallo*

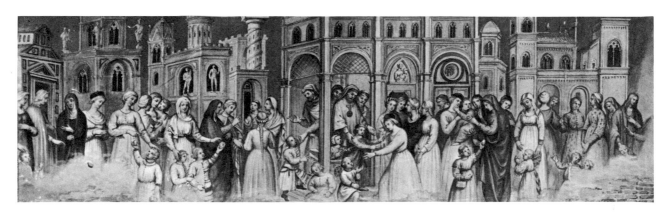

6. Fanciulli smaritti, *aquarelle after Gerini-Baldese fresco, before 1777. Florence, Bigallo*

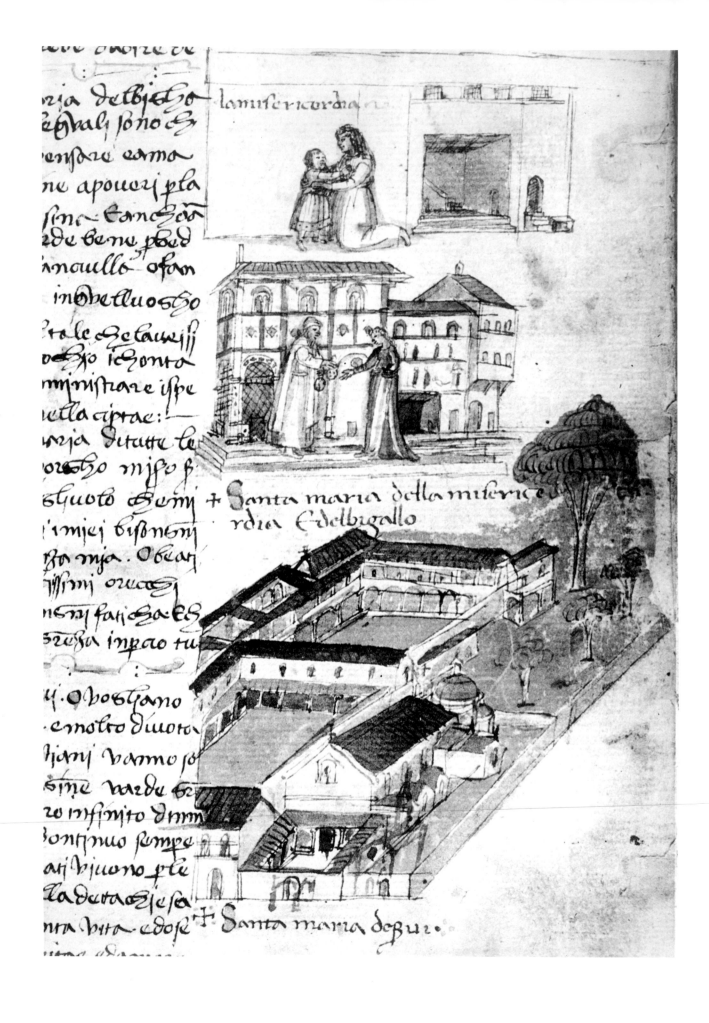

la misericordia

+ Santa maria della misericordia Edelbigallo

+ Santa maria deBur..

8. Ridolfo Ghirlandaio, predella panel with view of Bigallo oratory and residence, 1515. Florence, Bigallo

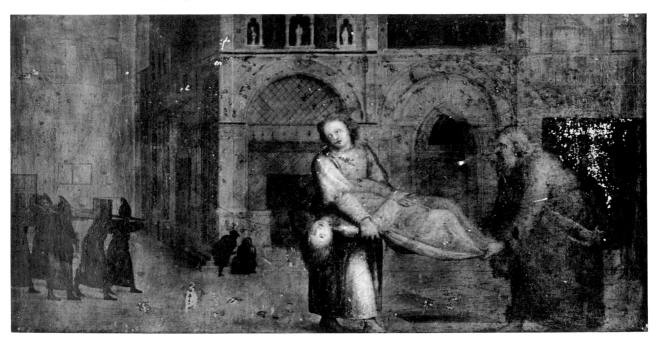

9. Francesco Granacci, Fantastic View of Piazza del Duomo and Baptistery with Bigallo, *ca. 1515. Florence, Uffizi, No. 3* Paesi

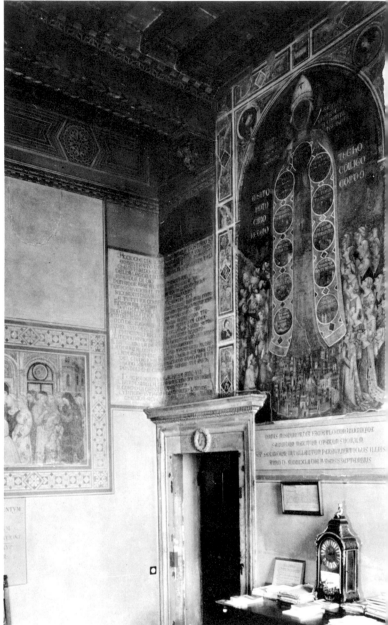

10. *Florence, Bigallo, old* udienza
(present Sala del Consiglio),
state after 1777

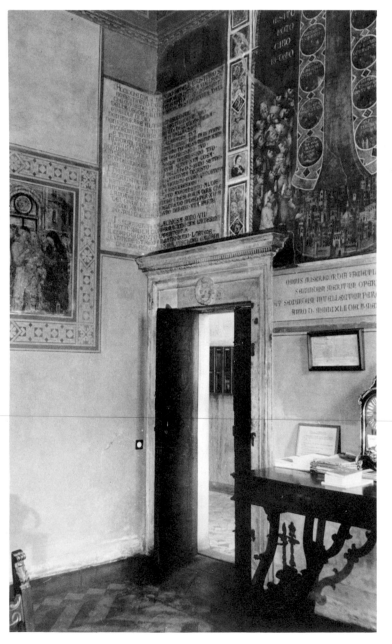

11. *Florence, Bigallo, old* udienza:
Misericordia *fresco (1342)*
on west wall at right;
Gerini-Baldese fresco fragment on
south wall (inserted 1777) at left

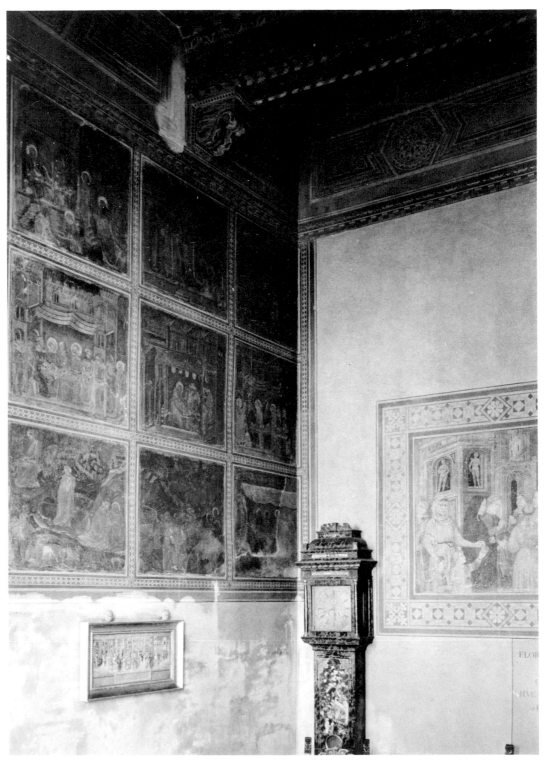

12. *Florence, Bigallo, old* udienza, *east wall with Tobias* cycle and aquarelle copy of Gerini-Baldese fresco below

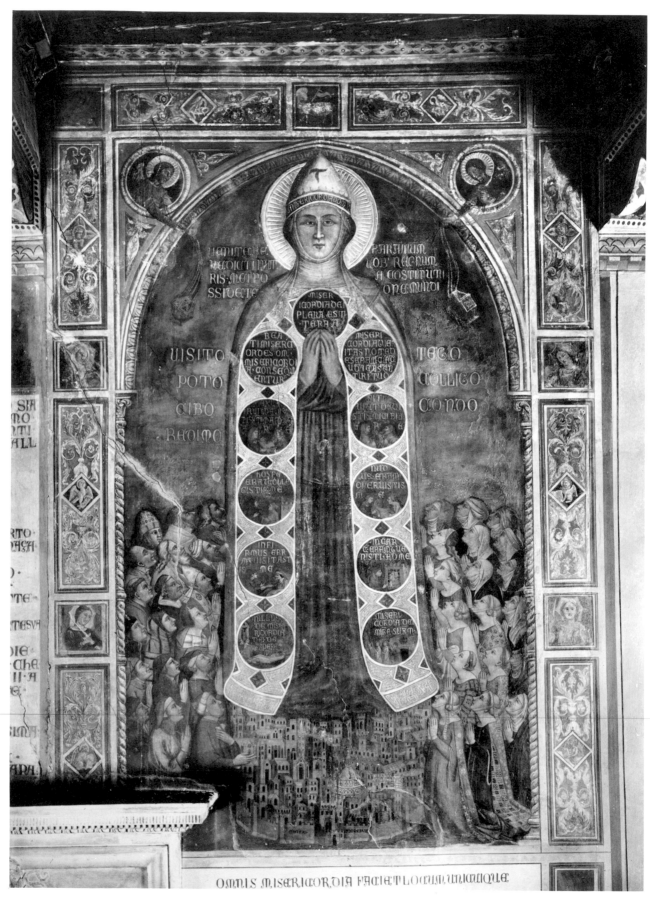

13. *Florence, Bigallo, old* udienza, Misericordia *fresco, 1342*

14. Florence, Bigallo, residence corridor

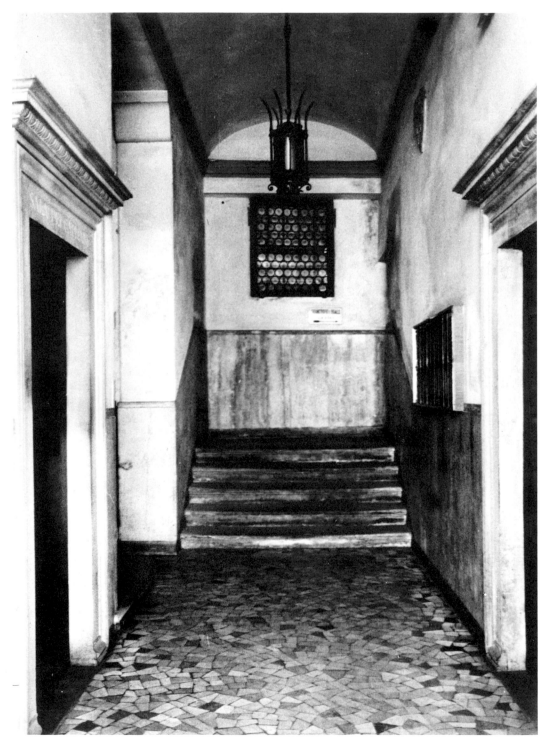

15. Florence, Bigallo, residence stairway

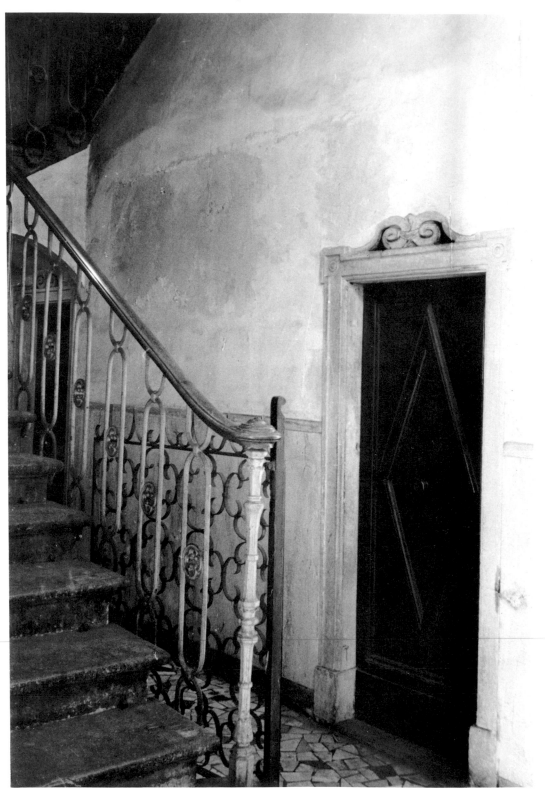

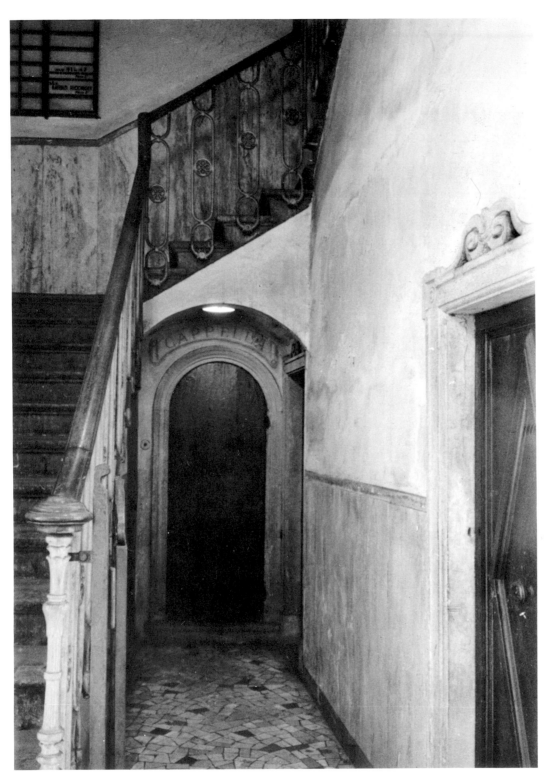

16. *Florence, Bigallo, residence stairway, modern door to sacristy in rear center*

17. Florence, Bigallo, oratory, sala magna on upper floor

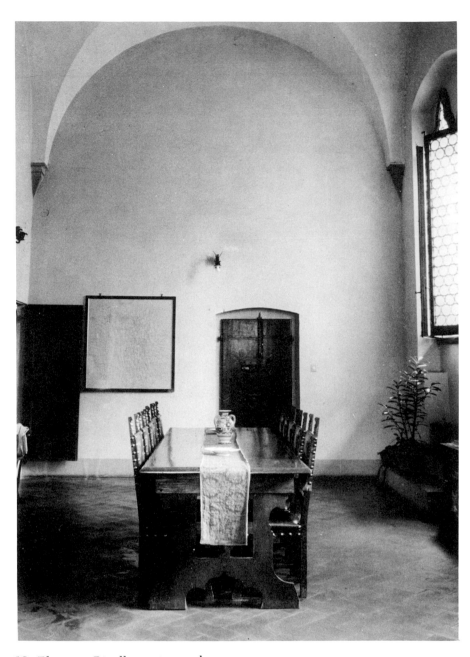

18. *Florence, Bigallo, oratory*, sala magna

19. *Florence, Bigallo, oratory*, sala magna,
console capital

20. *Florence, Bigallo, oratory*, sala magna,
console capital

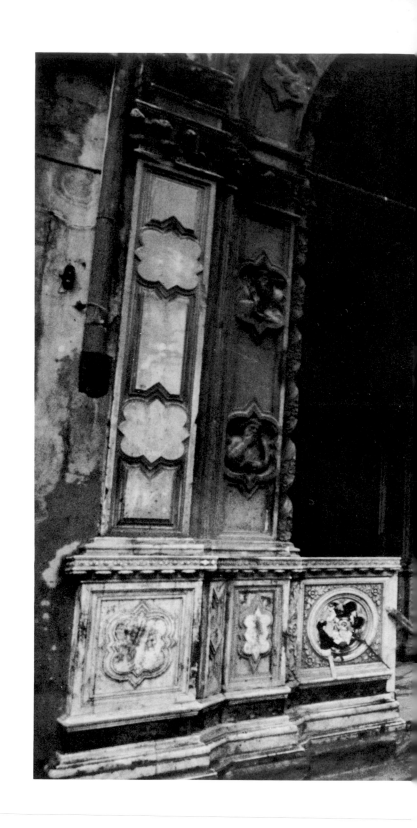

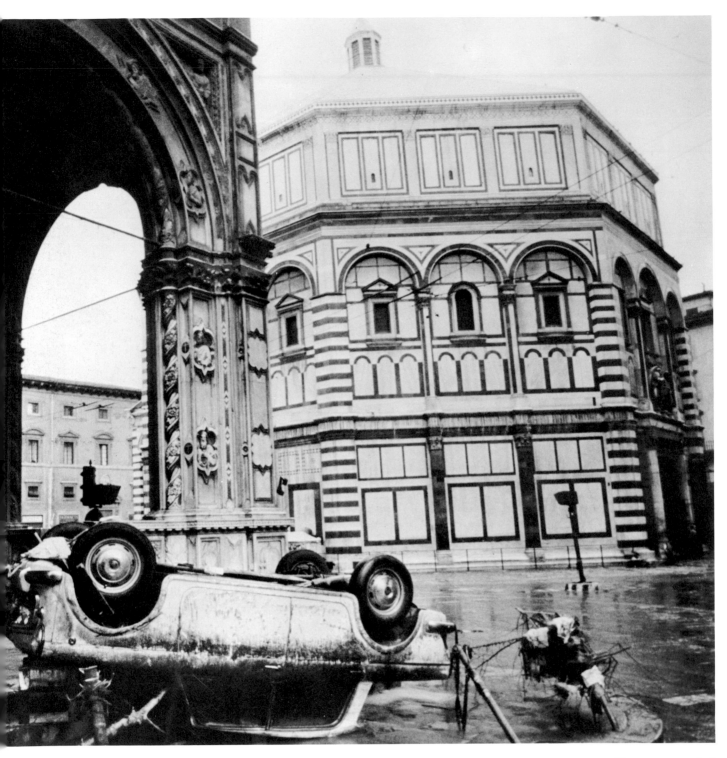

21. Florence, Piazza San Giovanni, after the flood of Nov. 4, 1966. Bigallo oratory at left